SAN FRANCISCO
49ERS

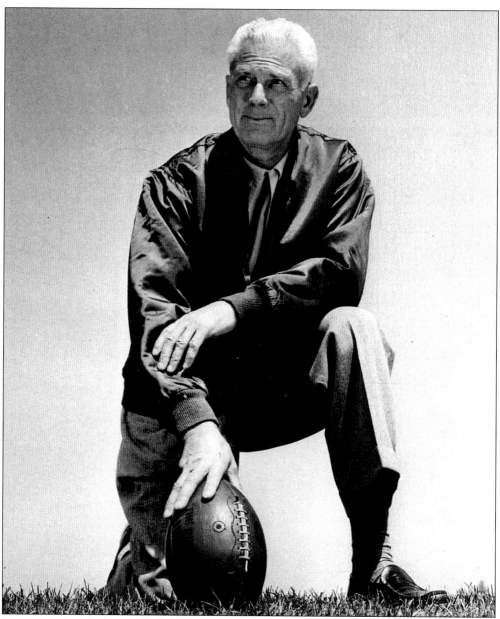

Lawrence "Buck" Shaw, called the "Silver Fox" (because of his gray hair), was a local legend who gave the 49ers instant credibility when he became their first coach in 1946. He then led his team to immediate success in the All-America Football Conference (AAFC) and turned it into an NFL winner as well.

SAN FRANCISCO
49ERS

Martin Jacobs

ARCADIA

Published by Arcadia Publishing
Charleston SC, Chicago IL, Portsmouth NH, San Francisco CA

Printed in Great Britain

Library of Congress Catalog Card Number: 2004116365

For all general information contact Arcadia Publishing at:
Telephone 843-853-2070
Fax 843-853-0044
E-mail sales@arcadiapublishing.com
For customer service and orders:
Toll-Free 1-888-313-2665

Visit us on the internet at http://www.arcadiapublishing.com

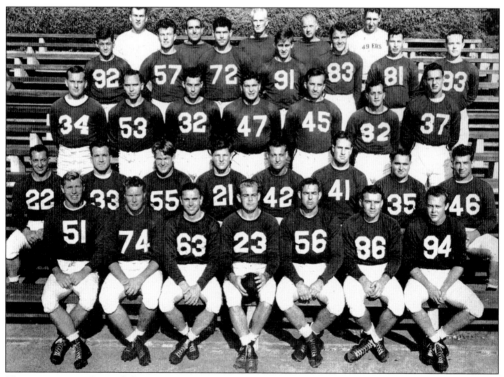

Here is a team shot of the 1946 49ers. Pictured, from left to right, are (front row) Titchenal, Roskie, Albert, Remington, Fisk, Mathews, and Parsons; (second row) Coulee, Banducci, Elston, Bryant, Woudenberg, Thornton, and Kuzman; (third row) Forrest, Beals, Gregory, Grgich, Mellus, Franceschi, and Palich; (fourth row) Vetrano, Balatti, Standlee, Strzykalski, Casanega, Eshmont, and Durdan; (back row) Zamlynsky, Ruffo, Shaw, Lawson, and Kleckner.

CONTENTS

ACKNOWLEDGMENTS

I would like to express my appreciation to Bill Fox, Jack McGuire, Gabriella Harmer, Joannie Bassett, Acme Pictures, Mike Traverse, Don Sinn, Marty Arbunich, Russell Moshier, Charles Cushere, Cal-Pictures, the *San Francisco Chronicle*, the *San Francisco Examiner*, Frank Ricci, Reginald McGovern, Tommy Thompson, Terrell Lloyd, Frank Rippon, Lee Sussman, David Wilkie, and Allan Gandy for their assistance with information and photo images for this book. I would like to send a special thanks to Jan Boehm for her expertise editing and Denise and John York and the San Francisco 49ers for their support in the production of this book.

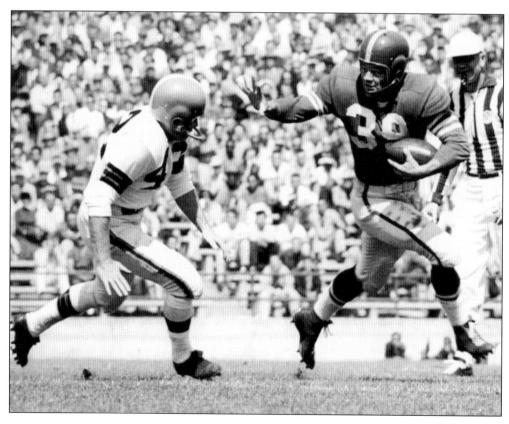

For Hugh McElhenny, who gave me the inspiration to make this book possible.
Long live "The King"—the greatest running back ever!

INTRODUCTION

Since the days of the gold rush, San Francisco has been known for its spirit of adventure and restlessness, and in 1946 it lived up to that reputation. The city offered something for everyone—a growing metropolis, brawling spirit, friendly climate, and a unique culture. Tourists came from everywhere to ride the cable cars, visit the Golden Gate Bridge, and feast on San Francisco's famous sourdough bread and Dungeness crab while washing it down with a hearty beer.

At the time, the professional sports business was dominated by the East Coast, and perceived the West Coast as just a giant picturesque national park. San Francisco seemed to have a solid footing with a new pro football franchise called the San Francisco Clippers in the Northern Division of the Pacific Coast Pro Football League. However, after its inaugural season in 1946, interest in the league declined and by 1949 the Clippers called it quits.

San Francisco was also a hotbed of college football. Crowds stormed the gates of Kezar Stadium in Golden Gate Park to see The Wonder Teams of California-Berkeley versus the Wow Boys of Stanford, led by Frankie Albert in the revolutionary T-formation. St. Mary's, Santa Clara, and the University of San Francisco were also colorful football powers that regularly beat the University of Washington and Southern California University, and played their games at Kezar.

The National Football League (NFL) at that time had no teams west of Chicago and no plans for the West Coast. But in the fall of 1944, Tony Morabito, a San Francisco businessman, and some of his associates went to Chicago and filed an application for an expansion team in San Francisco. Elmer Layden, the presiding league commissioner, and one of the original "Four Horsemen of Notre Dame," turned down Morabito's request. Morabito was still convinced that San Francisco was ready to support a professional franchise.

Shortly thereafter, Morabito visited Arch Ward, the sports editor of the *Chicago Tribune*, who was organizing a new rival league, the All-American Football Conference (AAFC). Morabito told him San Francisco was ready to join the AAFC. A meeting was held in St. Louis with Ward, and Morabito agreed to form a San Francisco franchise on June 6, 1944—D-Day in Europe. Play was to start after the end of World War II.

Allen Sorrel, one of Morabito's two partners, suggested the team name be "49ers" as a tribute to the prospectors who had rushed west for gold. He also discovered a photo of an inebriated miner firing a pistol into the air; it became the team's first logo. Together they inaugurated the formation of the San Francisco professional football club.

The legendary coach, Buck Shaw, winner of two Sugar Bowls with Santa Clara, was hired as their first head coach. Lou Spadia was brought on as the general manager. The 49ers were fortunate to sign players who were well known to San Francisco fans, such as Frankie Albert, Norm Standlee, and Bruno Banducci of Stanford; Alyn Beals, Visco Grgich, and Ken Casanega of Santa Clara; and Johnny "Strike" Strzykalski and Joe Vetrano from the fourth Air Force team.

There were 32 players on the first 49er team roster of 1946. Their biggest man was fullback Norm Standlee, and his 230 pounds is considered very light by modern day football standards. The 49er quarterback was Frankie Albert, who had the kind of character San Franciscans could appreciate—a smallish left-hander with a gift for ad-libbing plays.

In the four football seasons of the AAFC (1946–1949) the 49ers finished second to Paul Brown's Cleveland Browns, but they established themselves as a dominant team. Their cumulative record was an excellent 39-15-2. They appeared in the playoffs and championship game for the first time in 1949.

Following the collapse of the AAFC, the 49ers moved to the NFL in 1950. Their original management team, co-owners Tony Morabito and Vic Morabito, and general manager Lou Spadia, remained intact.

The 49ers struggled in their NFL debut, winning only three games in their inaugural season. The media described them as "not big enough or tough enough." Yet, in an amazing reversal of form, they fought back and posted a respectable 63-54-3 during the 1950s. The closest the 49ers came to a championship in their first two decades of NFL play was in 1957, when they tied Detroit for the Western Division crown but lost in the playoff.

The 1960s were the least successful decade in 49er history. They flirted with success in the early 1970s when they won three straight NFC Western Division titles, but were eliminated each year by the Dallas Cowboys. For the first time the 49ers finished with more defeats than victories, with an overall 57-74-7 record. During the 25 years the 49ers played at Kezar (1946–1971), they registered a 95-61-7 regular-season record.

Finally, in 1971 the 49ers moved their home games from antiquated Kezar to 68,491-seat Candlestick Park, where they play today.

On March 31, 1977, a new era dawned for the 49ers when Edward J. DeBartolo Jr. became the new owner. DeBartolo dedicated himself to transforming the team into a dynasty. Upon his purchase of the club, he began a process of upgrading the organization's front-office administration and on-field talent. His vision was to create a winning franchise that operated with class and dignity.

DeBartolo hired Bill Walsh, renowned as an offensive specialist, as head coach. Three seasons later, the 49ers claimed their first championship with a 26-21 win over the Cincinnati Bengals in Super Bowl XVI.

San Francisco won the Western Division again in 1983, but saved their best for 1984. That year, they won 18 of 19 games, including Super Bowl XIX when they beat the Miami Dolphins 38-16.

Walsh ended his professional coaching career after San Francisco's 20-16 victory over Cincinnati in Super Bowl XXIII. In 10 years as the 49ers' coach, Walsh had a 102-62-1 record, and won six NFC West titles and three Super Bowls.

Furthermore, the 49ers of the 1980s were stocked with superstars: quarterback Joe Montana, wide receivers Jerry Rice, tight end Dwight Clark, running back Roger Craig, and defensive backs Ronnie Lott and Eric Wright. DeBartolo and the 49ers earned the moniker "Team of the 80s" after claiming four Super Bowl titles during that decade. They extended their dominance into the 1990s, becoming the only NFL team to produce 10 or more wins (including postseason) in 16 consecutive seasons (1983–1998).

George Seifert, who replaced Walsh, continued to take advantage of the existing talent he inherited. Careful personnel moves ensured that capable new players were on hand when veterans retired. Seifert's record as the 49ers' head coach was superior. Between 1989 and 1996, he led the 49ers to a regular-season record of 108-35, and wins in Super Bowls XXIV and XXIX.

In January 1997, Seifert was replaced by Steve Mariucci, who took the team into the playoffs in three out of five seasons, winning the Western Division title three times. In 2002, the 49ers entered the season with high hopes of advancing to the playoffs. The team accomplished its mission of winning 11 games and advancing to the NFC Divisional playoffs with the second largest playoff comeback in NFL history, beating the New York Giants 38-37.

The 49ers opened its sixth decade in the NFL under new leadership with the transfer of ownership from Eddie DeBartolo Jr. to his sister, Denise DeBartolo York. In 2003, head coach Steve Mariucci was released and Dennis Erickson was hired to be his successor as the 14th 49er head coach in team history.

ONE

Off to a Running Start

As a member of the AAFC in 1946, the 49ers were determined to sign good players while building a team from scratch. They were supremely challenged by having to compete against the powerful NFL. And they knew full well what it would entail.

Frankie Albert had been drafted by the Chicago Bears in 1942, but did not report because of his commitments to the Navy. After Albert finished his tour of duty, he signed with the 49ers instead. The Bears underwent additional grief when Norm Standlee, a fullback on the 1941 Bears' championship team, defected to the 49ers.

Parker Hall and Len Eshmont, another pair of ex-NFL luminaries, abandoned their respective teams to join the 49ers. Bruno Banducci, the ex-Stanford and Eagles guard, deserted Philadelphia for San Francisco. This powerful nucleus of stalwart 49ers took off in high gear as a club on August 24, 1946, defeating the Los Angeles Dons 17-7 in their first preseason game in San Diego. The following week they downed the Chicago Rockets 34-13 in their San Francisco debut. The 49ers finished the season with a 9-5 record, good enough for second place in their division—not bad for a newborn competitor scratching for the first time in the AAFC field.

In the spring of 1947, there was breaking news of a possible trade with the Los Angeles Dons involving Frankie Albert and Army's Touchdown Twins, Glenn Davis and Tom Blanchard. The trade was squashed, though, as the Army refused them both furloughs to play for the 49ers.

The 49ers started off the 1947 season with almost the same players as the previous year. Again they finished second to the Cleveland Browns in their division with an 8-4-2 record. The 49ers couldn't beat either the Browns or Yankees in four attempts, and suffered ties with Baltimore and Buffalo. However, the home crowds were increasing as a record 54,325 came out to watch Otto Graham and the Browns beat the 49ers once again, 14-7.

After a second successful season, Shaw made sweeping changes in 49er team personnel in 1948, bringing in 19 rookies. They included Joe Perry, Bill Johnson, Gail Bruce, Forrest Hall, Veryl Lillywhite, Don Clark, Hal Shoener, and Jim Cason.

The 49ers went undefeated in their first 10 games, and then pummeled the Yankees 41-0 at Kezar before a sellout crowd. The team was averaging five touchdowns a game when they faced the undefeated Browns before a record 82,729 fans in Cleveland. The Browns once again prevailed, 14-7, knocking the 49ers from first place. A few weeks later, the Browns struck again by beating the 49ers 31-28, eliminating them from a division title. The 49ers finished with a 12-2 record and were tagged with another second-place honor.

The 49ers in 1948 established three all-new pro records: 495 total points scored, 3,844 yards gained rushing, and 5,767 yards of total offense. Albert set an AAFC record with 29 touchdown passes. End Alyn Beals, running back John Strzykalski, and tackle John Woudenberg were All-Pro first-team selections.

On the field, the 49ers of 1949 took up where they left off the year before. Led by Joe Perry's rushing and Alyn Beals receiving, they won four of their first five games. On October 9, the 49ers bumped heads with the mighty Browns, who had won 26 straight games, including three

ties, since losing in October 1947. Jammed into Kezar, 60,000 frenzied fans watched the 49ers dominate of the Browns, routing them 56-28. Joe Perry had his best day rushing for 156 yards.

The following week the 49ers clipped the Bills 51-7, but lost one of their star running backs, Johnny Strzykalski, to a broken leg. Still, the 49ers earned a playoff berth by beating the Colts, Dons, and the Yankees to close out the season with a 9-3 record.

The 49ers made their first playoff appearance on December 4, 1949, and beat the Yankees 17-7 to set up a showdown with the Browns in Cleveland. The game was played in miserable weather and the 49ers lost 21-7. Each 49er had earned a grand total of $172.61 that memorable day.

The defeat was overshadowed by the stunning news that the AAFC had folded, but for the 49ers the news was a blessing in disguise. San Francisco, Cleveland, and Baltimore were invited to join the ranks of the elite NFL. This was what Tony Morabito had hoped for all along.

From the clubhouse to the front office, not a whit of change needed to be made as a consequence of the merger. The NFL greeted the 49ers with open arms, and the San Francisco teammates could sense their pocket change growing rapidly in eager anticipation.

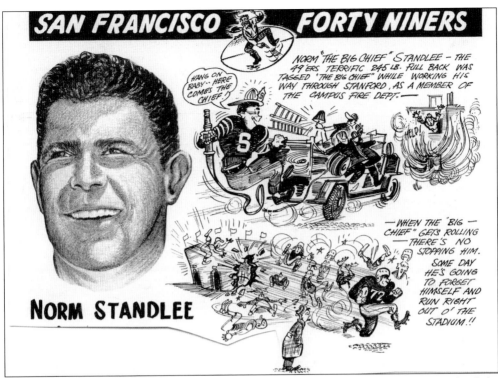

Fullback Norm Standlee (no. 72), at 6-foot-2 and 245 pounds, was known as the "Big Chief" for living over a firehouse. He was the 49ers first team captain and came to them after World War II to become a fullback and a bone-crushing inside linebacker.

Frankie Albert (no. 63), the "T" formation wizard at 5-foot-10 and 170 pounds, was the first 49er quarterback in 1946. He was a Bay Area hero from the Stanford University Rose Bowl team and dazzled the crowds with his magic. He was All-Pro from 1946 to 1950. After his playing days were over, he coached the 49ers from 1956 to 1958.

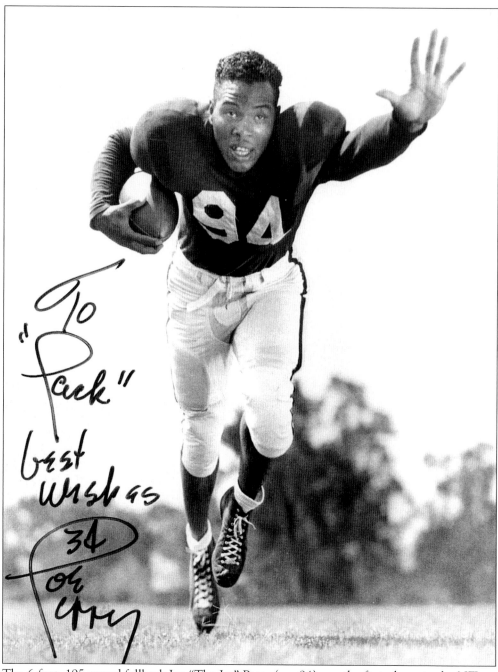

The 6-foot, 195-pound fullback Joe "The Jet" Perry (no. 94) was the first player in the NFL to gain 1,000 yards in two consecutive seasons (1954–1955). His 7,344 rushing yards places him first in 49ers all-time rushing. Perry finished his career with 12,505 combined yards. Perry had 18 100-yard games during his career and is tied with Roger Craig with 50 career rushing touchdowns. Perry was inducted into the Hall of Fame in 1970.

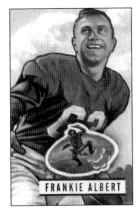

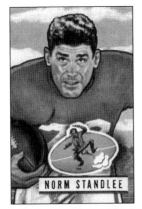

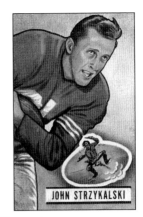

FRANKIE ALBERT

NORM STANDLEE

JOHN STRZYKALSKI

These are original 1946 49er player gum cards produced by the Bowman Gum Company.

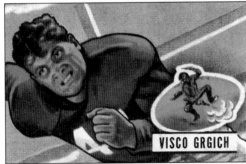

VISCO GRGICH

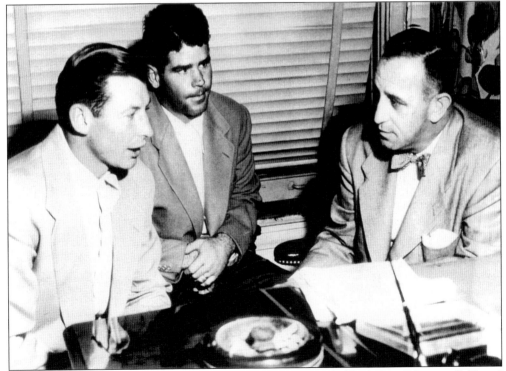

Owner Tony Morabito has a conference with 49er standouts halfback Len Eshmont (left) and fullback Norm Standlee (center) at his Stockton Street office in San Francisco to discuss salary issues.

The team's original logo depicted San Francisco's wild beginnings. It consisted of a prospector, clad in boots and a lumberjack shirt, firing a pair of pistols. One shot just misses the miner's head, while the other misses his foot. The logo was taken from a design seen on the side of railway freight cars. In that picture, the prospector was in front of a saloon, though the 49ers dropped the saloon from the logo.

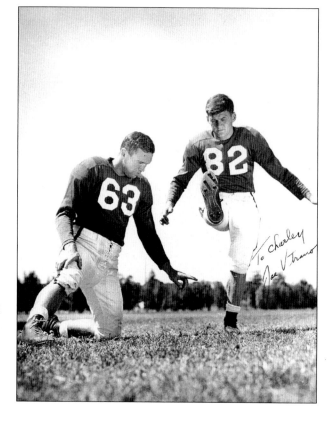

Frankie Albert holds the ball for place kicker Joe "the Toe" Vetrano (no. 82). Kicking specialist Vetrano played for the 4th Air Force Flyers during World War II before joining up with San Francisco in 1946. As a 49er, Vetrano held the kicking position from 1946 to 1949; his record of 104 consecutive extra points was an AAFC record.

The 6-foot-3, 225-pound Bob Bryant (no. 42) was from Texas Tech and started at tackle from 1946 to 1949. Bryant was known for his fierce tenacity and was an aggressive blocker and tackler on both sides of the ball.

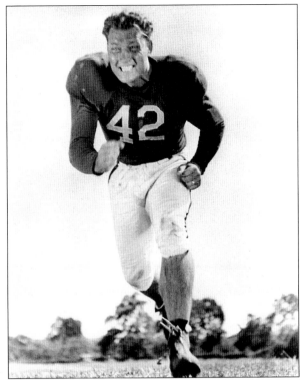

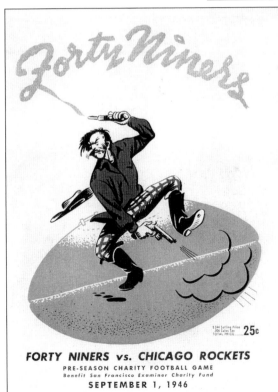

$244 Selling Price
.006 Sales Tax
TOTAL PRICE........ 25c

FORTY NINERS vs. CHICAGO ROCKETS

PRE-SEASON CHARITY FOOTBALL GAME
Benefit San Francisco Examiner Charity Fund

SEPTEMBER 1, 1946

The 49ers first ever preseason home game was played on September 1, 1946, at Kezar Stadium. The 49ers beat the Chicago Rockets 34-14 before 34,000 thrilled spectators. The reaction to big-time pro football in San Francisco was heartening. The 49ers had entertainment value, poise, power, and a dazzling offense.

15

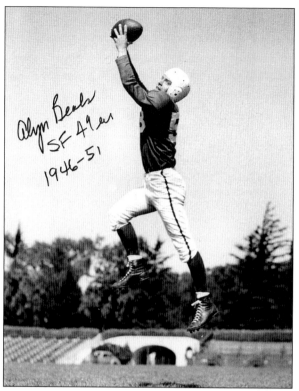

End Alyn Beals (no. 53) was signed as a free agent for $5,000 in 1946 and became one of the 49ers' greatest receivers. The 6-foot, 190-pound Beals led the AAFC in 1946 with 40 catches and 10 touchdowns. In his four years of playing in the AAFC, Beals scored 46 touchdowns and was the league's all-time leading scorer with 278 points while catching 177 passes from Frankie Albert.

Center Gerry Coulee (no. 22) and halfbacks Ken Casenega (no. 83) and Don Durdan (no. 93) help bring down the Brooklyn Dodgers halfback John Colmer after a short gain in the 49ers 63-40 win.

Halfback Johnny "Strike" Strzykalski (no. 91), at 5-foot-9 and 190 pounds, was the 49ers leading rusher in 1947 and 1948, gaining over 900 yards each year during the 12-game season. He broke his nose eight times before he retired in 1952. He was a 60-minute player and ranked fourth as the all-time AAFC rusher with 2,454 yards (a 5.7 average), and 14 touchdowns.

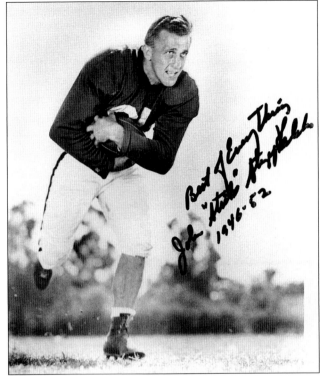

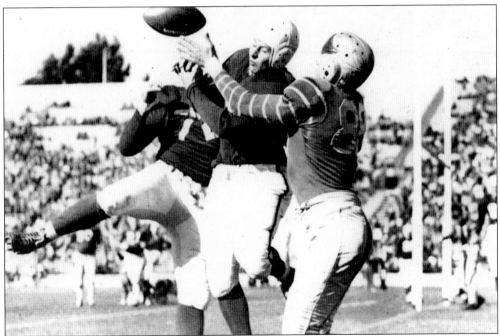

Defenders Len Eshmont (center) and Norm Standlee (no. 72) battle a Buffalo Bisons receiver (no. 88) for the ball in the 49ers 27-14 win at Kezar Stadium in 1946. Eshmont led the team in interceptions with six in 1947. He also played running back on offense, rushing for 1,181 yards and 7 touchdowns in his 4 seasons with the 49ers.

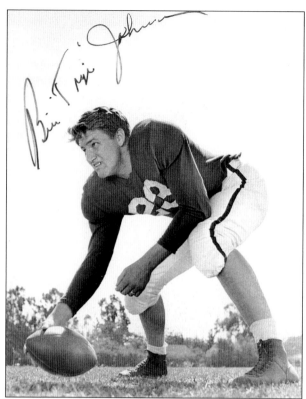

Bill "Tiger" Johnson (no. 23) signed as a free agent in 1948. The 6-foot-2, 210-pound Johnson became the starting center for the 49ers from 1949 to 1956. He was an excellent blocker for Frankie Albert and for Y.A. Tittle. He was selected to the All-Pro team in 1949 and appeared in 1952, 1953, 1954, and 1955 Pro Bowls.

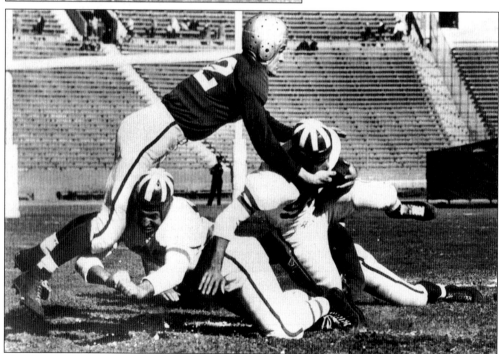

49ers halfback Paul Crowe (no. 92) stretches out to tackle the Don's halfback Herman Wedemeyer around the head and shoulders in the 49ers 38-21 defeat of the L.A. Dons at Los Angeles in 1948.

Visco Grgich (no. 47) signed on as a free agent in 1946 and established himself as the 49ers' best middle guard. The 5-foot-11, 220-pound Grgich played both ways on offense and defense throughout his career in the AAFC. He played middle guard in the NFL until he retired in 1952. He was All-Pro in 1949 and was selected to the 1950 Pro Bowl.

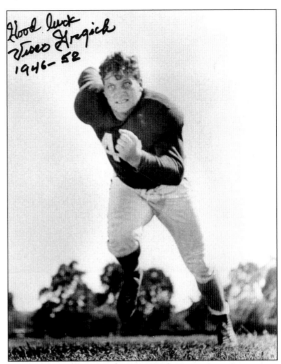

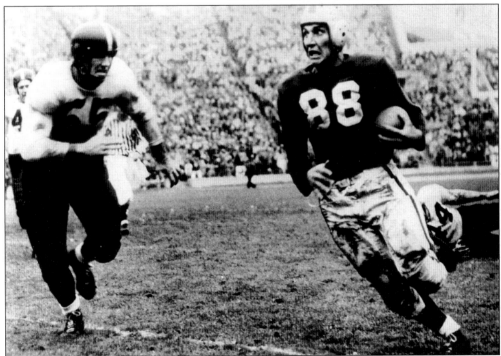

5-foot-11, 188-pound halfback Don Garlin (no. 88) sweeps around end for eight yards as New York Yankees Van Davis closes in to make the tackle. The 49ers rolled over the Yanks 35-14 at Kezar that day in 1949. In Garlin's short career with the 49ers (1949–1950) he rushed for 116 yards with a 4.8 average.

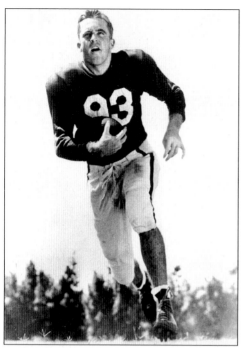

Jim Cason (no. 93) played offense and defense for the 49ers during his six-year career with the 49ers (1948–1952, 1954). The 6-foot, 168-pound Cason was drafted in the third round from Louisiana State University and was used mostly on defense. Cason also filled in at quarterback for Y.A. Tittle in the 1950s. He was selected All-Pro in 1948 and led the team with 9 interceptions in 1949 and rushed for 351 yards during his career.

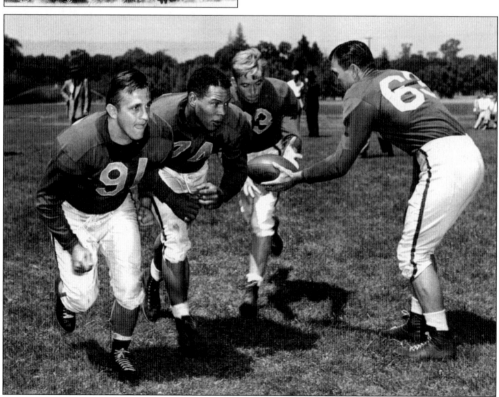

The 1949 starting offensive backfield of halfback Johnny Strzykalski (no. 91), fullback Joe Perry (no. 74), halfback Jimmy Cason (no. 93), and quarterback Frankie Albert (no. 63) practice handoffs at Menlo College during training camp.

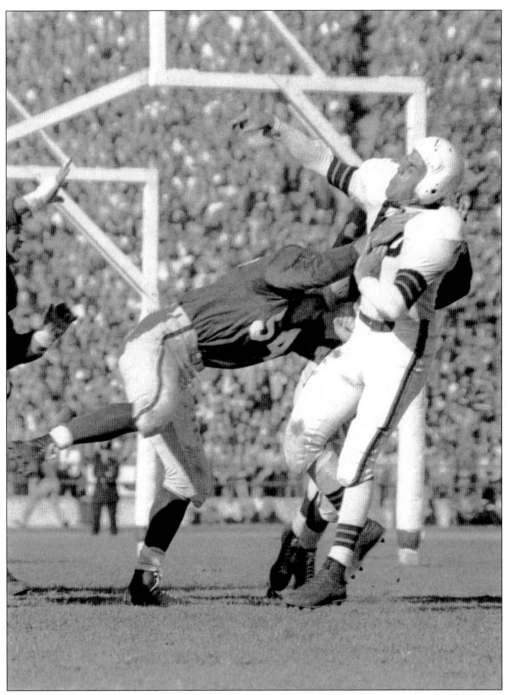

Guard Visco Grgich (no. 34) and end Gail Bruce put the pressure on Cleveland Browns quarterback Otto Graham as he attempted to pass during the 49ers 56-28 win in San Francisco. The win was especially rewarding for the 49ers as the Browns and 49ers had met five times prior to this 1949 game and only once had the 49ers been able to beat Cleveland. The last time was in their inaugural year of 1946 in which the 49ers won 34-20.

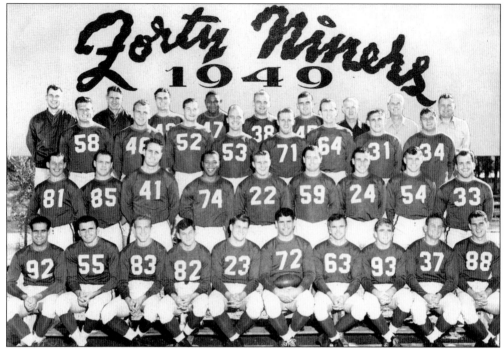

This 1949 team photograph shows, from left to right, (front row) Wagner, Salata, Cathcart, Vetrano, Johnson, Standlee, Albert, Cason, Hobbs, and Garlin; (second row) Eshmont, Carr, Woudenberg, Perry, Wismann, Maloney, Sabuco, Bruce, and Banducci; (third row) Susoff, Evans, Shoener, Beals, Lillywhite, Wallace, Clark, and Grgich; and (back row) Zamlynsky, Morgan, Mike, Carpenter, Quilter, Lawson, Shaw, and Erdelatz.

Joe Perry (no. 74) sweeps around Cleveland Browns defenders as 49ers Guards Bruno Banducci (no. 33) and Riley Matheson (no. 37) lead the way for Perry. Perry had a record-breaking day by gaining 156 yards on the ground as the 49ers had 561 total yards of offense in their huge victory 56-28 in 1949.

49ers halfback Eddie Carr (no. 85) defends a pass intended for the Baltimore Colt's Al Davis in the 49ers 56-14 win at Kezar in 1948. Carr, with no college experience, came out of Olney High School in Philadelphia to start for the 49ers. He had 16 career interceptions during his 3-year stint (1947–1949) with the 49ers.

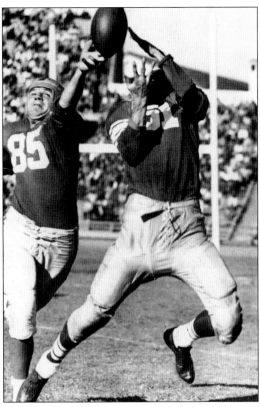

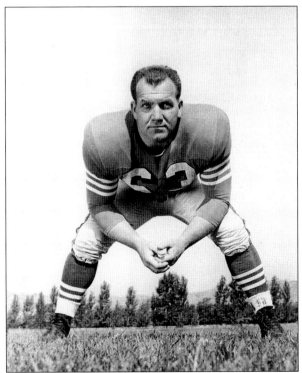

The 5-foot-11, 220-pound guard Bruno Banducci (no. 63) was captain of the original 49ers and played 9 years (1946–1954). He was an All-Pro in 1946–1947 and 1952–1954. He was selected to the 1946–1947 AAFC All-Star squads and played in the 1954 Pro Bowl.

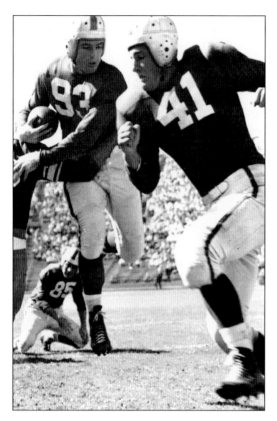

Halfback Jim Cason (no. 93) picks up four yards against the Baltimore Colts in a 49ers 28-10 win at Kezar in 1949. Tackle John Woudenberg (no. 41) leads the blocking while Eddie Carr (no. 85) is seen in the background.

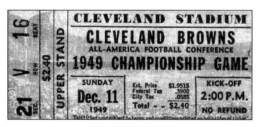

Above is a 1949 AAFC Championship game-ticket stub. Pictured at right is the December 11, 1949 49ers-Browns AAFC Championship game program. The game was played in snow and slush before 22,550 freezing fans in Cleveland. The Browns won the game 21-7, revenging their 56-14 loss earlier in the year to the 49ers in San Francisco. The 49ers' only score in the title game came from a 24-yard scoring pass from Albert to end Paul Salata.

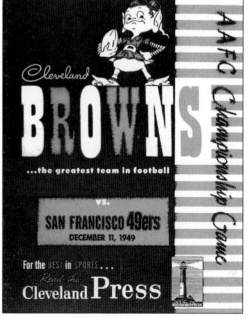

Two
Kezar Stadium

When the San Francisco 49er football team formed in 1946, it needed a stadium to play in. The owners chose Kezar Stadium as their new home. It had been built in the 1920s on a narrow strip of land, nestled among the high oak trees bordering Golden Gate Park, which gave it a picturesque setting. It remained the home of the San Francisco 49ers for more than two decades (1946–1970).

In 1922, $100,000 was accepted from the estate of Mary A. Kezar to erect a memorial to her mother and relatives. The San Francisco Park Commission accepted these funds and appropriated an additional $200,000 to build a stadium. Construction began and was completed a year later. Dedication ceremonies were held at Kezar Stadium on May 2, 1925, with a two-mile race held at the venue. The stadium was one tier of bleachers that held 59,942 fans and circled the entire field. All the seats were wooden benches, and if fans didn't rent a cushion for 25¢ they were sure to get splinters.

The 49ers played their first home exhibition game on September 1, 1946, against the Chicago Rockets, drawing a crowd of 34,000. On game day, the Golden Gate Bridge and Bay Bridge were filled with cars, trucks, and vans carrying fans from as far away as 200 miles.

It seemed like a ready-made box-office attraction, because ticket prices were affordable and season tickets were discounted. Prices ranged from $3 for the four sections around the 50-yard line, to $2 for other sideline seats, and $1 for end-zone seats. A season-ticket buyer could get seven games for the price of six for $18. Even so, the 49ers sold only 858 season tickets in their inaugural season and lost $144,000 their first year, hardly a negligible amount back in post-war 1946.

A few games had to be scheduled on Saturdays instead of Sundays, drawing less than 10,000 fans, because the colleges still had first call on Kezar Stadium for their big games. It was hardly an auspicious beginning for the San Francisco 49ers.

Still Kezar had its charm. Each year the 49ers opened up in August, with the best weather months being September and October. The early season games at Kezar were especially pleasant. On a clear day, the sun would start setting above the west rim of the stadium. Then the glare would drive the quarterbacks and receivers crazy, while young men in the stands would take off their shirts to soak up the sun. But, by the fourth quarter, the cold bite of the Pacific Ocean fog would cut through, sending the bare-chested fans back into full attire to avoid frostbite. The cold weather became the ultimate 49er fan's stimulant.

The pride in this team was unquestioned, and each 49er fan was jovial, warm, and steadfast. In fact, 49er fans were considered to be the most amiable fans in the league. Yet, the so-called Kezar "boo-birds," a few unruly drunken fans, were the 49ers' avant-garde. Because of them, the players' tunnel at the east end of the stadium had to have a wire cage erected around it to protect the players. Exuberant fans would douse the visiting players with beer and soda.

At times riots broke out, as in a game in 1953 when the Philadelphia Eagles and 49ers got into a melee. The players had their helmets off swinging them at each other. Usually, however, after the games the players from both sides were friendly and mingled with the fans on the field. It seemed there was never a dull moment at the stadium.

Kezar was equipped with the usual concession stands selling hot dogs and sodas, but the lines seemed endless. If you left your seat to buy food and drink, you'd miss a whole quarter of football standing in line. Parking? There was plenty of room in Golden Gate Park, but if the game was played on a weekday, one could expect to walk a mile or two to reach the stadium.

The 49ers never won a championship at Kezar. Many fans felt it was a "jinx" for them. In fact, in the first 10 years, the 49ers changed the colors of their helmets five times and style of their uniforms three times. "Wait 'til next year!" became the familiar characteristic chant of the 49er fans.

Despite never winning a title, Kezar will always be remembered by the early 49er faithful as "cardiac alley." In 1957, the famed "Alley Oop" pass play from quarterback Y.A. Tittle to receiver R.C. Owens was showcased at Kezar. This play in particular caused six heart attacks during the 1957 season alone. It was a play in which the ball was just tossed up in the air by Tittle, and Owens was able to out-jump his defenders for the ball—usually in the waning moments of the game. This was easily the most spectacular play ever during the two decades the 49ers played at Kezar.

1957 was also an exciting, emotional season for the 49ers. Owner Tony Morabito died of a heart attack just after halftime of the Bears game on October 27 at Kezar. The 49ers dedicated the rest of their season to Morabito, and they ended up tied for the Western Division title with the Detroit Lions.

The 49ers played 24 seasons at Kezar Stadium before moving to Candlestick Park in 1971. The team played their last game at the stadium on January 3, 1971, against the Dallas Cowboys.

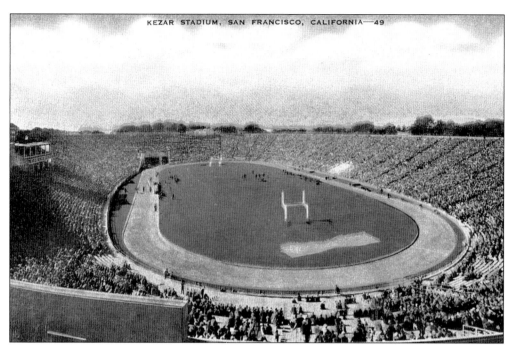

Kezar Stadium was the home of the San Francisco 49ers from 1946 until 1971. Dave Scofield was the stadium announcer and Bud Foster did the play-by-play on KYA radio during the formative years (1946–1953). Then Roy Storey, Tom Harmon, Bob Fouts, and Lon Simmons shared the broadcasting and telecasting on KSFO.

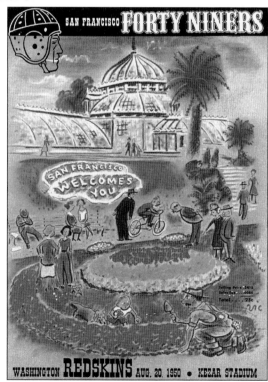

Pictured is the first official 49er NFL pre-game program. The 49ers debut was on August 20, 1950, against the Washington Redskins with 51,201 in attendance. Loyal fans watched the 49ers lose their home opener 31-12. Unfortunately, the Redskins were clearly superior in every section of play on this day.

27

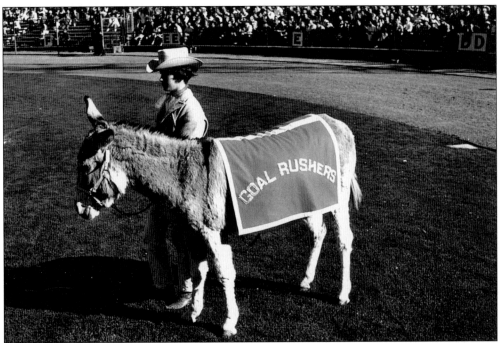

The first mascot of the 49ers was a mule named Clementine (named after an 1849 prospectors mule). Clementine paraded around the sidelines during 49er home games at Kezar. Though the mule was calm, it was not uncommon to see him kick up his back heels and let out a howl when the 49ers scored—which was often.

SAN FRANCISCO
FORTY NINERS

760 MARKET STREET . SAN FRANCISCO, CALIFORNIA 94102

Welcome Forty Niner fans to the first ever NFL game played at Kezar today. It is indeed a pleasure to play in the National Football League.

Under the able guidance of our management, the Forty Niners have established an enviable record in professional football. They could not of achieved this success without the whole-hearted support of you San Francisco fans and the press and radio.

I have long been an admirer of Coach "Buck" Shaw and I know he will produce a team that will give an excellent account of itself against all opponents.

Many stirring NFL games are in store for Kezar Stadium, beginning with today's contest with the Washington Redskins. The best of luck to the Forty Niners—we're ready to go!

CO-OWNER
SAN FRANCISCO 49ERS

A letter sent to 49ers fans from co-owner Tony Morabito welcomes the 49ers into the NFL.

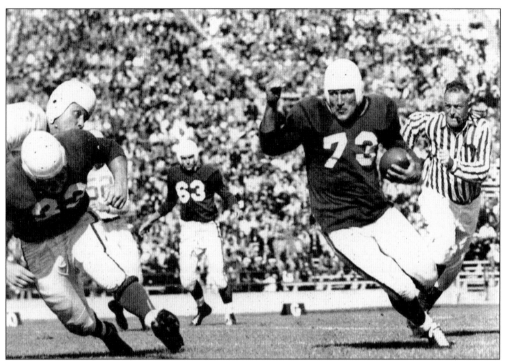

Halfback Dick Renfro (no. 73) heads up field against the Chicago Rockets in the first game played at Kezar Stadium in 1946. Bruno Banducci (no. 33) lays a crushing block as Frankie Albert (no. 63) looks on.

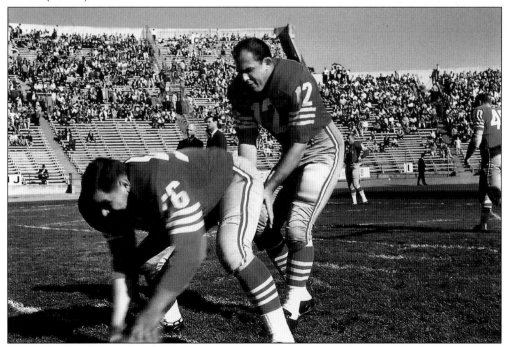

Quarterback John Brodie takes pre-game warm-up snaps at Kezar Stadium. Brodie performed in many memorable games at Kezar during his 17-year career as a 49er (1957–1973).

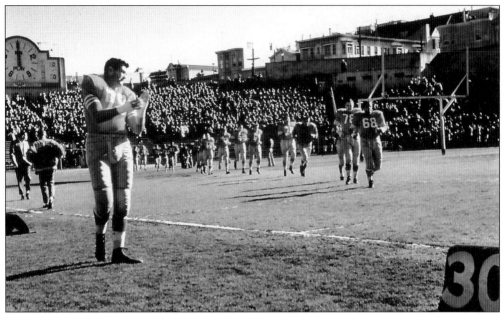

Offensive captain, tackle Bob St. Clair (no. 79), welcomes the 49ers team onto the field at Kezar during the 1957 opening ceremonies. St. Clair played 17 years and 189 games on the field at Kezar: 2 years with Polytechnic High School, 3 at University of San Francisco, and 12 in the NFL for the 49ers. The field was re-named in his honor January 18, 2001, as Bob St. Clair Field.

The 43-piece 49ers marching band (including a 36-girl precision drilling and twirling corps called the Majorettes), organized in 1953, was an integral part of every 49ers home game. In the 1970s the 49ers organized the 49er Nuggets, a 20-member volunteer cheerleading team. In 1983 they were replaced with the "Gold Rush," and expanded to a 32-member dance team. The 49ers band was directed by Joe McTigue, who performed at pregame and postgame festivities for the fans at Kezar.

Halftime at Kezar was always a festive affair. Michael Olmstead was the director as top-rated college, armed forces, and high-school marching bands, drill teams, drum corps, and similar units performed for 49ers fans. Most guests were invited to appear on the basis of their performances at civic events, competitions, and parades. Even Bob Hope, star of screen and radio, made a special guest appearance at halftime and exhibited his rare skill—booting field goals. The fans gave him a tremendous ovation for his antics.

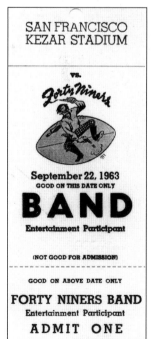

This was the official band pass issued to all band members before all 49ers home games.

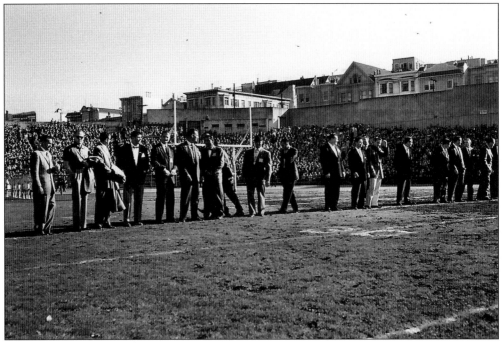

Over 100 49er alumni, including Frankie Albert, Norm Standlee, Alyn Beals, Bruno Banducci, Visco Grgich, Hardy Brown, Nick Feher, Don Burke, Al Carapella, Ken Casenaga, Art Elston, Dick Renfro, Eddie Carr, Bob Hantla, Billy Mixon, and Jim Cason showed up at Kezar to be honored during the 10-year anniversary celebration (1946–1956).

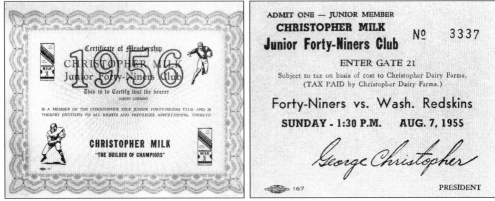

At left is the Christopher Milk Jr. 49ers club certificate. Named after mayor George Christopher, the club was located at the northwest end of the stadium. By joining the Milk Club, children and young adults were entitled to a club membership card, a certificate, free game tickets, and a chance at a raffle to win 49er prizes. On the right is a ticket coupon for admission to the Christopher Milk Section.

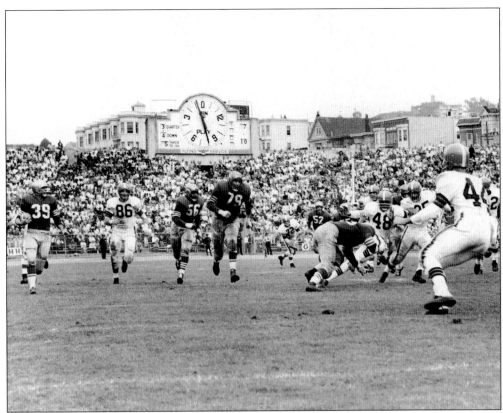

In this 1957 photo, halfback Hugh McElhenny (no. 39) carries the ball against the Cleveland Browns in the third quarter at Kezar as Bob St. Clair (no. 79) leads the way. The large scoreboard and clock were located at the east end of the stadium.

Kezar Stadium, or "Cardiac Alley," was known for its heroics and often left the large crowds in a frenzy with their last-second victories. As far as tradition goes, the reporters who covered 49er action for the local newspapers at Kezar were Bob Brachman (*San Francisco Examiner*), Jack McDonald and Walt Daley (*Call Bulletin*), Bud Spencer and Roger Williams (*San Francisco News*), and Bill Leiser and Art Rosenbaum (*San Francisco Chronicle*).

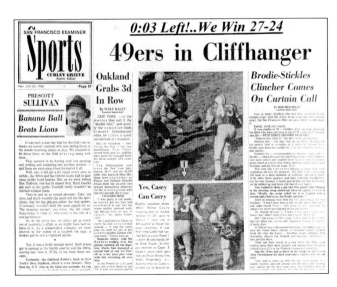

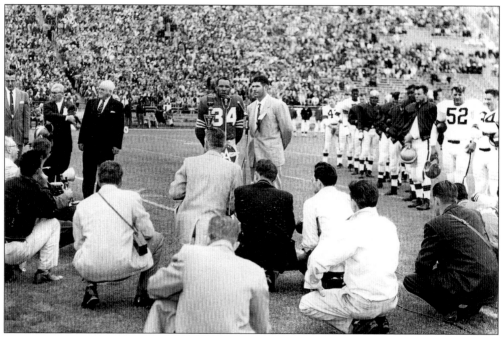

Joe Perry Day was held at Kezar on August 28, 1955. Here, 49er Norm Standlee acts as master of ceremonies honoring 49ers legend Perry, whose career spanned 14 years (1948–1960, 1963). He was elected into the Hall of Fame in 1969.

49ers postgame activities gave a chance to mingle on the playing field with players, coaches, and fans. The 49ers band, located at the west end of the playing field, usually entertained the fans for about 30 minutes after each home game. The fans' most requested song was "When the Saints Come Marching in" and, of course, the 49er fight song, "The Football Polka."

THREE
The Fabulous 1950s

In 1950, the 49ers stood on the threshold of a decade of great change and high hopes. Their players were soon among the first to fly in commercial jets and perform on television, and they became national heroes. The age really was golden. Sports writers and fans predicted the 49ers would contend for the NFL title in their first season in the league—instead they were overwhelmed. They lost seven games in a row, including the last two preseason games and the first five of the regular season. They finished with a dismal 3-9 record.

Rookie tackle Leo Nomellini and receiver/place kicker Gordy Soltau were the bright spots, but Frankie Albert typified the 49ers 1950 collapse: he threw for only 14 touchdowns and a career-high 23 interceptions. After the season, Y.A. Tittle was drafted by the 49ers from a "bonus" draft pool and they got back into the swing of things.

The 49ers had their first quarterback controversy during the 1951 season. Tittle was pressed into action almost immediately because of a shoulder injury to Frankie Albert.

Albert began the season as the starter, but Tittle and Albert began alternating, which caused fans to split with different opinions. Neither quarterback had a terribly notable year as Albert finished with 10 interceptions and just 5 touchdown passes; Tittle had 9 interceptions and 8 touchdown throws. Yet it was Tittle who started the last three games to finish second in the Western Division.

Tittle established himself as the heir apparent at quarterback. Halfback Hugh McElhenny was drafted by the 49ers in 1952, beginning a new era of excitement for fans. McElhenny would play for the next eight seasons. In his first play as a 49er, during the preseason opener against the Chicago Cardinals at Kezar, McElhenny ran 42 yards for a touchdown. He would rush for 684 yards, a 7-yard average, and caught 26 passes for the season on his way to being named Sport Magazine's Player of the Year. The 49ers raced to a 5-0 record, but were to lose four of their next six games. Albert who was then 38, decided to call it quits and retired.

The 49ers' misfortune in the early years of their franchise was exemplified by the 1953 season. They had a chance to tie the Detroit Lions after winning their last four games, but came up short once again, finishing second. Charley Powell, a part-time boxer and starting defensive end was good enough to receive All-Pro mention.

The 49ers didn't win many games in 1954, but they assembled one of the greatest backfields ever, whom 49er publicist Dan McGuire labeled the "Million Dollar Backfield." In fact, a million dollars in those days might have been the entire team budget for player salaries for several seasons. The backfield was Tittle, McElhenny, Perry, and John Henry Johnson, who added to an already powerful backfield. Johnson finished second behind Joe Perry, who set a NFL record by rushing for 1,049 yards, for the second straight season. But injuries to Tittle and McElhenny cut into the 49ers' abilities and the team finished 7-4-1. Tony Morabito fired Buck Shaw at the end of the year. Shaw left with a record of 72-40-4, but still without a championship.

Norm "Red" Strader took over, bringing in Albert as one of his assistants. (Strader's tenure as coach lasted only one season that good enough for fifth place in the Western Conference.)

Unfortunately, 1955 was a season when the 49ers were plagued by injuries. Frankie Albert was named head coach for the 1956 season, but his debut was not auspicious. The 49ers lost five of their first six games. Albert's job was saved, however, as the 49ers went 4-5-1 the rest of the way. Still, the 49ers drew record attendance crowds, but that went unnoticed. Albert only lasted three seasons before quitting.

When they ran out of adjectives in attempting to describe the 49er team of 1957, the sportswriters finally resurrected the word "cliffhanger" as the "alley-oop" pass from Tittle to R.C. Owens accounted for victory after victory. In seven of their eight wins, the 49ers trailed in the second half. In six of those, they trailed in the fourth quarter, in five they trailed in the last four minutes, and in four they won in the last minute. Adding to the drama was the fatal heart attack suffered by team owner Tony Morabito during a game against the Chicago Bears. In an example of reality imitating bad fiction, the 49ers learned of Morabito's death at halftime, overcame the Bears a 17-7 lead, and won 21-17.

The 49ers finished strong to end the regular season tied with the Detroit Lions at 8-4. The 49ers lived by the sword during that 1957 season, and they died by it in a playoff game with the Lions for the Western Division Championship. They led 27-7 in the third quarter. Then the Lions exploded for three touchdowns and a field goal and the dream was shattered. The 49ers would go 12 more seasons before making another playoff game.

The 1958 season was both magical and heartrending. The 49ers suffered their worst defeat of the decade, 56-7 to the Rams, but rebounded to win three of their last four games to end up 6-6 for fourth place. And though the 49ers sampled bliss and disappointment that year, they seemed to both. In the last home game of the season the 49ers incurred their most decisive victory with a 21-12 win over the Champion Baltimore Colts. Joe Perry surpassed Steve Van Buren to become the all-time rushing yardage leader with 6,549 yards. And by season's end, Frankie Albert was replaced by assistant coach Howard "Red" Hickey to become the new head coach.

After a mediocre 1958 season, the 49ers prophets predicted dire forecasts for the 49ers of 1959. Gordy Soltau, the 49ers all-time scorer, had retired while Tittle, Perry, and McElhenny, once the stalwarts on the 49ers offense, were in the twilight of their careers.

Under their new coach, the 49ers jumped off to their best start since joining the NFL by winning six of their first seven games, including a 34-0 shutout of the Rams. Then things went bad in a hurry. They dropped four of their last five games and ended the year tied for third place in the West. The 49ers ended the decade with 63 wins, 51 losses, and three ties.

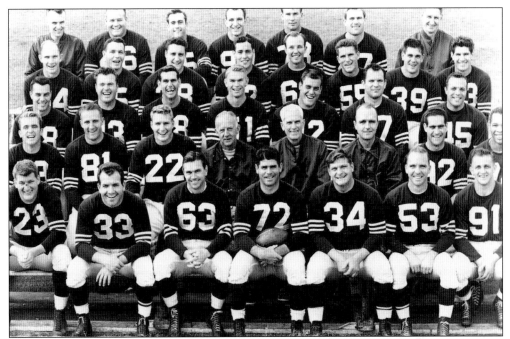

This 1951 49er squad was sparked by a group of rookies: 6-foot-2, 220-pound guard Nick Feher (no. 37), 6-foot, 235-pound tackle Al Carapella (no. 45), 6-foot-4, 225-pound Ed Henke (no. 47), 6-foot, 190-pound receiver Bill Jessup (no. 55), 6-foot, 190-pound quarterback Y.A.Tittle (no. 64), 6-foot-3, 195-pound end Billy Wilson (no. 58), 5-foot-11, 190-pound defensive back Rex Berry (no. 83), 6-foot, 196-pound linebacker Hardy Brown (no. 73), and 5-foot-11, 180-pound running back Pete Schabarum (no. 88). The 1951 49ers (7-4-1) were in the race until the season's final day.

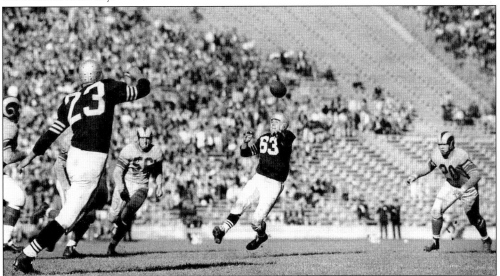

49er quarterback Frankie Albert (no. 63) throws a pass downfield intended for halfback Rex Berry (no. 23) in a 1952 regular-season game against the Los Angeles Rams at Kezar Stadium. Over the years, the 49ers and Rams became bitter rivals when the Northern and Southern California teams went head-to-head.

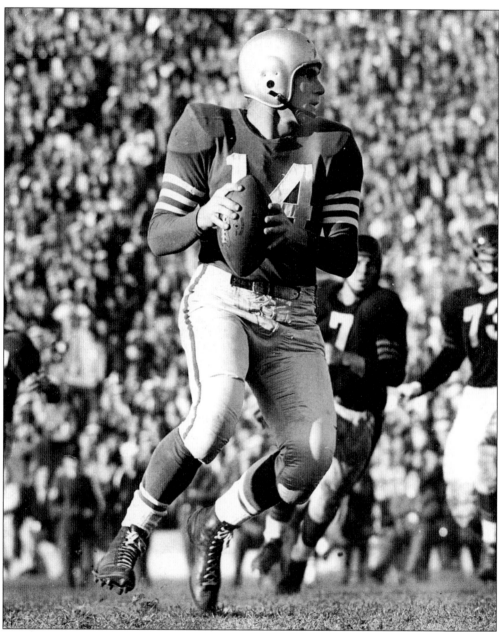

Quarterback Y.A. Tittle (no. 14), called "Colonel Slick," played for the 49ers for nine seasons, finishing his career with 16,016 passing yards and 108 touchdowns. Drafted no. 1 in 1951 after his Colts folded, Tittle was considered a great field general. In 1954, he was quarterback of the "Million Dollar Backfield" and was rated as one of the top quarterbacks in the league. He wasn't necessarily a touch passer, but he was an outstanding downfield passer. Even at 20 yards, Tittle was very accurate, and he could run the ball too as indicated with his 698 career rushing yards. Tittle left a football legacy in San Francisco after he was traded to the New York Giants in 1960, passing for 17,888 yards—almost 8 miles. He will always be remembered as a 49er for his "alley-oop" passes to end R.C. Owens. An All-Pro in 1953 and 1957, he was selected to the Pro Bowl in 1953, 1954, and 1957. In 1987 Tittle was elected to the Hall of Fame.

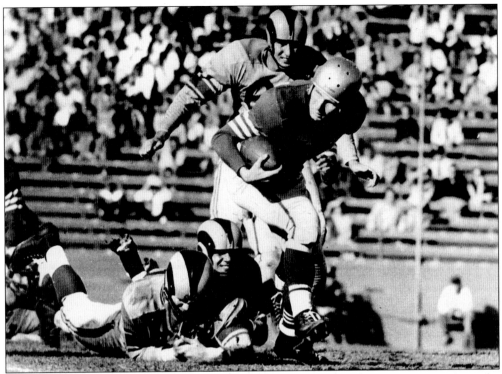

Y.A. Tittle avoids a Los Angeles Ram's pass rush as a host of tacklers try to bring down the 49er's first-year quarterback. After a 35-14 humiliation by the Rams in their inaugural 1950 NFL season, a Rams coach declared the 49ers weren't big enough or tough enough.

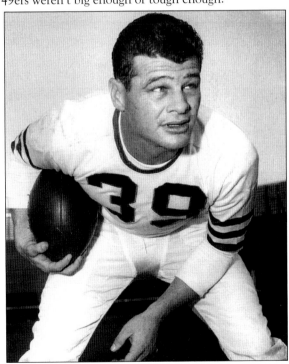

Running back Hugh "The King" McElhenny (no. 39) was the greatest "open field" runner of his time. The 6-foot-1, 198-pound McElhenny is one of only three players to gain over 11,000 yards carrying the ball. As a 49er, he scored 60 touchdowns, 38 of those via rushing, including a 42-yard touchdown run on his first pro play in preseason. In 1952, his rookie season, McElhenny had the longest punt return (94 yards), the longest play from scrimmage (89 yards), and was selected Player of the Year. He appeared in six Pro Bowls and was chosen All-Pro five times. McElhenny was inducted into the Hall of Fame in 1970.

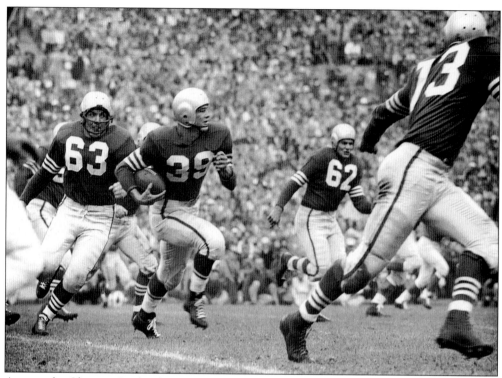

Against the Chicago Cardinals in 1952, rookie Hugh McElhenny (no. 39) follows his blockers Leo Nomellini (no. 73), Bob Toneff (no. 62), and Bruno Banducci (no. 63) on his 42-yard touchdown jaunt. The 49ers won the game 38-14.

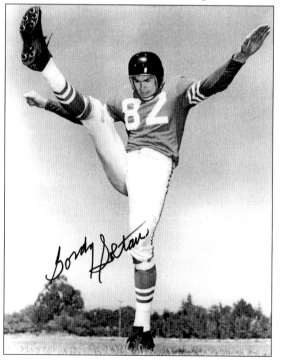

Gordy Soltau (no. 82) was a legendary end and kicker for the 49ers. In 1952, the 6-foot-2, 195-pound Soltau led the team with 59 catches for 826 yards and 7 touchdowns. In a game against the Rams in 1951, he scored 26 points (3 touchdowns, a field goal, and 5 extra points). Against the Rams in 1956, he kicked four field goals in the 49er's 33-30 win. In his career, Soltau had 249 receptions for 3,487 yards and 25 touchdowns to score a total of 641 points (70 field goals and 281 extra points). He was selected All-Pro in 1951–1952 and 1952–1953, and played in the Pro Bowl in 1952–1953.

The 49ers' head coach Buck Shaw (center), assistant coach Jim Lawson (left), and line coach Phil Bengtson look down at the playbook in 1953. When Shaw took over the 49ers in 1946, his first choice as his assistant coach was James "Wilmer Jim" Lawson, who earned All-America honors at Stanford in 1924 and later barnstormed with Red Grange's New York Yankees. After the war, Lawson joined the 49ers. Bengtson came to the team in 1950 after serving as the assistant coach at Stanford where he helped turn out the modern "T-formation."

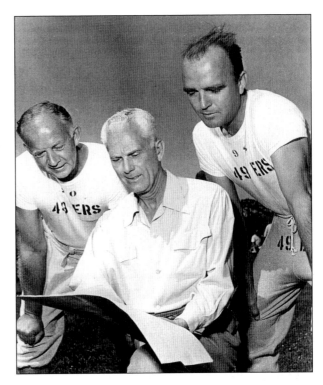

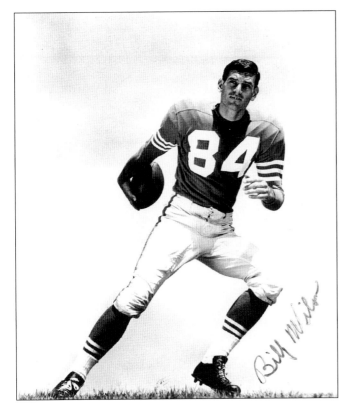

Beginning in 1952, the 6-foot-3, 195-pound Billy "The Goose" Wilson (no. 84) was the 49ers leading receiver for most of his career. Teaming up with Y.A. Tittle, Wilson led the team in receiving six times between 1951 and 1960. In 1955, Wilson tied for the most catches among receivers in the NFL with 53, then led in 1956 with 60 and again in 1957 with 52. Wilson finished his career with 360 receptions in 9 seasons as a 49er. He was All-Pro 5 times and appeared in 5 Pro Bowls, receiving MVP in 1955.

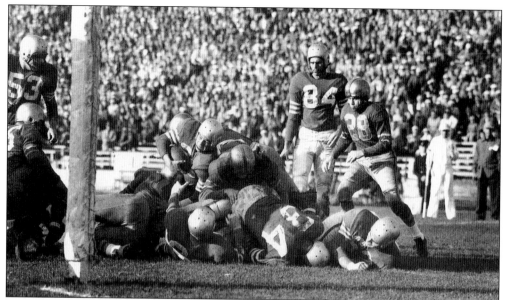

In the 1952 home opener against the Detroit Lions, before 52,750 spectators, Hugh McElhenny (no. 39), follows the blocks of Bruno Banducci (no. 63) and Joe Perry (no. 34) and dives over the goal line for a touchdown from the 1-yard line. Billy Wilson (no. 84) and Bill Johnson (no. 53) look on in what would be a 17-3 49ers win.

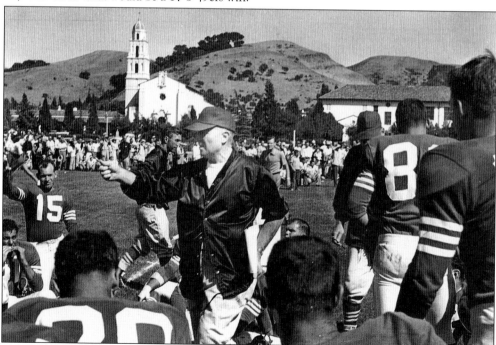

Backfield coach Norm Strader gives instructions to his offensive players during training camp at St. Mary's College in 1953. The 49ers also held training camps at the Polo Fields in Golden Gate Park and Menlo College (1946–1954), UC Santa Barbara (1968–1975), San Jose State (1976–1978), Santa Clara University (1979–1980), Sierra College in Rocklin (1981–1996), University of Pacific (1997–2001), and at their own current facilities in Santa Clara.

Some of the outstanding 1953 49ers are shown here, from left to right: guard Art Michalek (no. 62), linebacker Hardy Brown (no. 33), center Bill Johnson (no. 53), tackle Leo Nomellini (no. 73), and guard Nick Feher (no. 67). The 6-foot, 196-pound Brown was feared by his opponents because of his ferocious "shoulder tackles" that knocked his opponents unconscious.

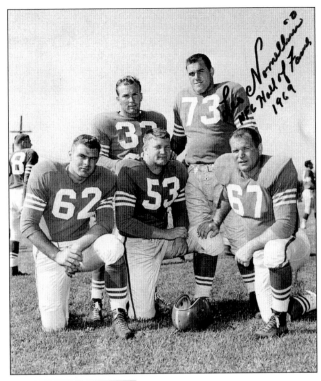

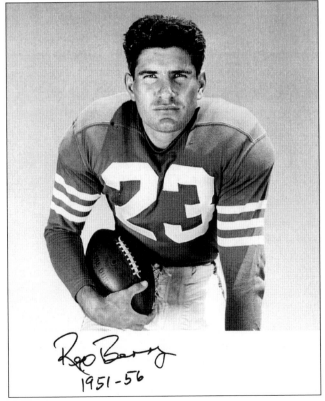

All-purpose halfback Rex Berry (no. 23), was a 49ers team captain and intercepted 22 passes during his 6-year career with the 49ers (1951–1956). In 1953, he had seven interceptions to lead the team, and in 1956 Berry ran 44 yards to a touchdown with an interception against the Detroit Lions.

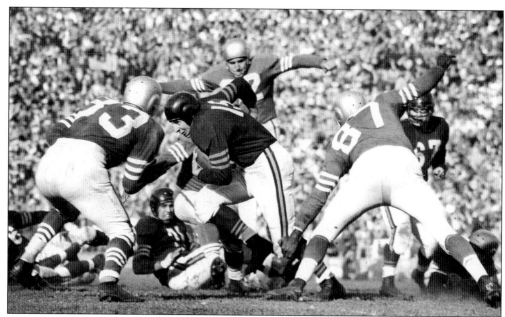

The 5-0 49ers met the Chicago Bears on November 2, 1952. Here Bears fullback Fred Morrison gains six yards in the fourth quarter. 49ers guard Don Burke (no. 32), linebacker Hardy Brown (no. 33), and end Charley Powell (no. 87) close in for the tackle. The 49ers held a 17-10 lead at the beginning of the fourth quarter, but Frankie Albert, the punter, decided to run the ball instead of punt on fourth down. He was stopped short of a first down and the Bears thereafter scored a tying touchdown and went on to kick a game-winning field goal to win 20-17.

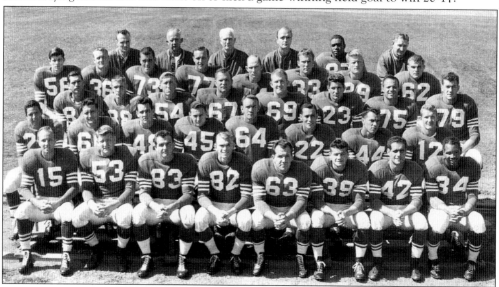

This 1953 49ers team photo shows, from left to right, (front row) Powers, Johnson, Matthews, Soltau, Banducci, McElhenny, Wagner, and Perry; (second row) Bahsen, Burke, Mixon, Bruney, Hogland, Arenas, Schabarum, and Ledyard; (third row) Wilson, Babcock, Manley, Feher, Smith, Berry, Carapella, and St. Clair; (fourth row) Brown, Morton, Nomellini, Miller, Tittle, Brown, Van Doren, and Michalik; (back row) Clark, Lawson, Shaw, Bengtson, Powell, and Kletchner.

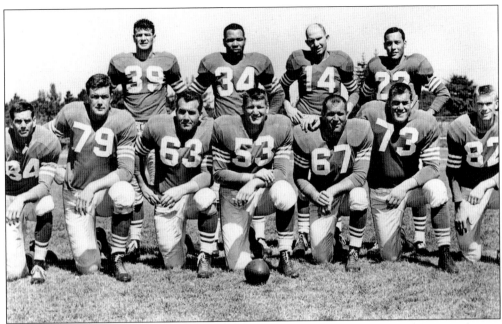

Here is the 1953 starting offensive lineup to open the season. Pictured, from left to right, are end Billy Wilson (no. 84), tackle Bob St. Clair (no. 79), halfback Hugh McElhenny (no. 39), guard Bruno Banducci (no. 63), fullback Joe Perry (no. 34), center Bill Johnson (no. 53), Y.A. Tittle (no. 14), guard Nick Feher (no. 67), tackle Leo Nomellini (no. 73), end Gordy Soltau (no. 82).

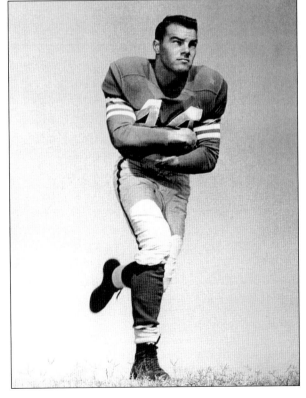

The versatile halfback Pete Schabarum (no. 44), starred at the University of California Berkeley and played in three straight Rose Bowls before he was drafted by the 49ers in the second round. The 5-foot-11, 185-pound Schabarum had an excellent rookie year in 1951, rushing for 311 yards and two touchdowns while playing every backfield position for the 49ers (1951–1953, 1954), including kickoffs and punt returns. In his career he rushed for 494 yards and caught 20 passes for 3 touchdowns.

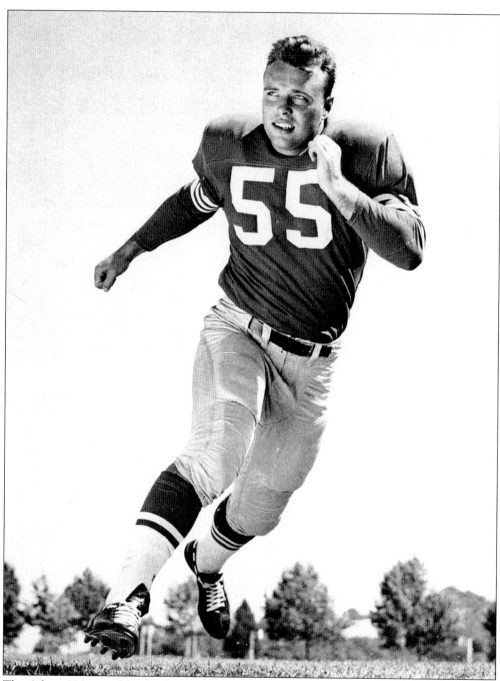

The 6-foot, 220-pound linebacker Matt Hazeltine (no. 55) was called the "Iron Man" of the 49ers because of his endurance. He started in his 1955 rookie year, continuing for 14 straight seasons until his retirement in 1968. Hazeltine was drafted out of the University of California as a center, but quickly became one of the 49ers most outstanding linebackers. He played in 190 games and had 13 interceptions and 3 touchdowns. He was selected All-Pro six times (1959–60, 1962–1965) and played in the 1962 and 1964 Pro Bowls.

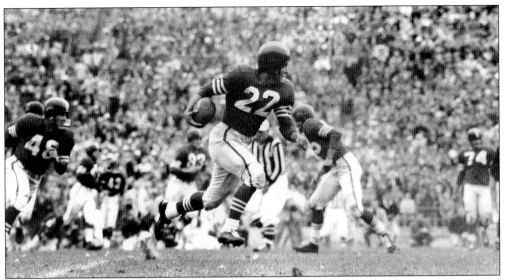

Amazing halfback Joe Arenas (no. 22), nicknamed "Ringo," electrified the crowds with his breakaway kickoff and punt returns. The 5-foot-11, 180-pound Arenas joined the 49ers in 1951 and quickly became the 49ers return man. In 1953, he led the league in kickoff returns with a 34.4 average. In his career he had 977 total yards rushing, with a 4.9 average and 10 touchdowns; 46 catches and 6 touchdowns; 124 punt returns for 774 yards; and a 27.3 kickoff return average. He retired in 1958.

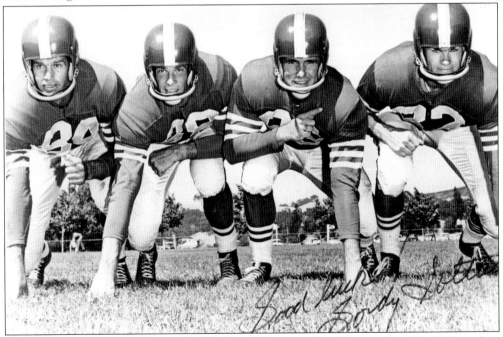

The highly regarded 49ers receiving corps in 1953 were, from left to right, Billy Wilson (no. 84), Harry Babcock (no. 88), Bill Jessup (no. 85), and Gordy Soltau (no. 82). During the season, Wilson led all 49ers receivers with 51 catches for 840 yards and a league-leading 10 touchdowns, Soltau had 43 catches for 620 yards and 6 touchdowns, and Babcock 7 catches for 59 yards. Jessup, however, was injured and out with a shoulder separation during the season.

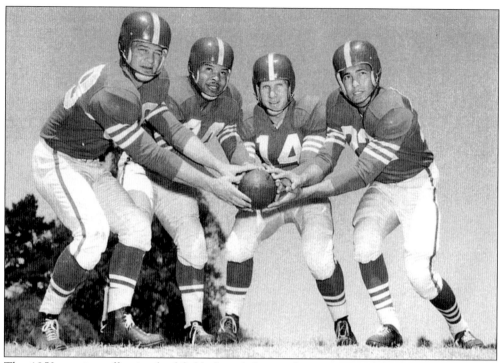

The 1953 starting offensive backfield, from left to right, was one of the best ever in 49ers history: Hugh McElhenny (no. 39), Joe Perry (no. 34), Y.A. Tittle (no. 14), and Joe Arenas (no. 22). During the season, Perry led all rushers with 1,018 yards and 13 touchdowns, while Tittle passed for 2,121 yards and 20 touchdowns.

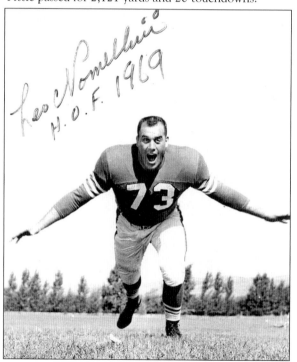

Tackle Leo "The Lion" Nomellini (no. 73) was the very first 49er draft pick in 1950. Nomellini played 14 years without missing a game until he retired in 1964. He was voted the greatest lineman in 49ers history by the Sports Writers of America and played both offense and defense. The 6-foot, 260-pound Nomellini combined pro football with an off-season career in wrestling and had three title matches with Champion Lou Thesz. He was All-Pro on offense and defense nine times (1951, 1954, 1957, 1959–1962), and was chosen for 12 straight Pro Bowl appearances (1950–1961). Nomellini was inducted in 1969 to the Hall of Fame.

A 15-minute, free-swinging donnybrook with the Philadelphia Eagles in 1953 was a bruising encounter. Both benches poured onto the field while two Eagle players singled out Hugh McElhenny (no. 39). With his helmet in one hand, McElhenny (dark jersey), and Eagles Pete Philos scuffle with one another.

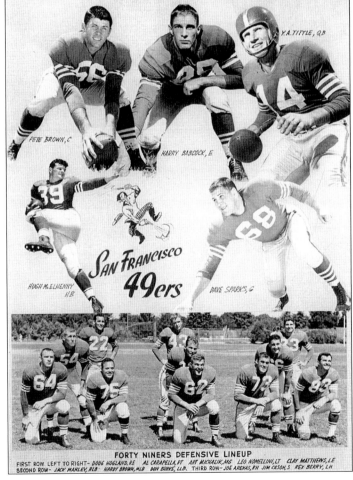

FORTY NINERS DEFENSIVE LINEUP
FIRST ROW LEFT TO RIGHT— DOUG HOGLAND, RE AL CARAPELLA, RT ART MICHALIK, MG LEO NOMELLINI, LT CLAY MATTHEWS, LE
SECOND ROW— JACK MANLEY, RLB HARDY BROWN, MLB DON BURKE, LLB. THIRD ROW— JOE ARENAS, RH JIM CASON, S REX BERRY, LH

Taken from the 25¢ game program distributed at 49ers home games is a collage of the 1953 49er offensive players that featured a group photo of the starting defensive players.

49

49er Hugh McElhenny tells quarterback Bobby Layne of the Detroit Lions to "get outa those fancy pants" as they both reported to Gilmore Field in Los Angeles to begin workouts for the 1953 East-West Pro Bowl game. Along with McElhenny, six 49ers were selected to play for the Western Conference: center Bill Johnson, guard Art Milchalik, tackle Leo Nomellini, fullback Joe Perry, end Gordy Soltau, and quarterback Y.A. Tittle.

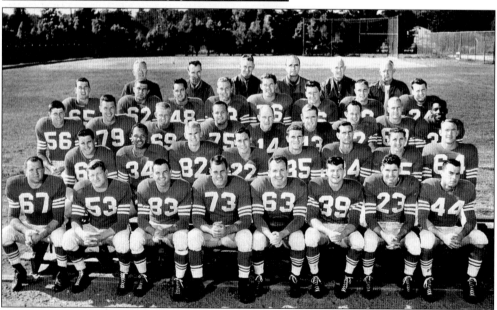

This photo shows the 1954 49ers. From left to right are (front row) Feher, Johnson, Matthews, Nomellini, Banducci, McElhenny, Berry, and Schabarum; (second row) Burke, Perry, Soltau, Arenas, Jessup, Wilson, Williams, and Hogland; (third row) P. Brown, St. Clair, Hantla, Carapella, Tittle, Cason, Duncan, Sagely, and J.H. Johnson; (fourth row) Connolly, Michalik, Mixon, H. Brown, Campbell, Brumfield, Babcock, and Tidwell; (back row) O'Grady, Clark, Kleckner, Bengtson, Shaw, and Lawson.

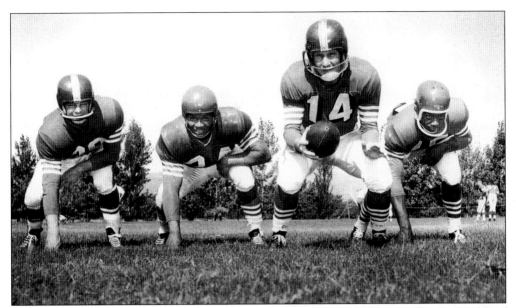

Shown here, from left to right, is the immensely talented 1954 "Million Dollar Backfield" of Hugh McElhenny (no. 39), Joe Perry (no. 34), Y.A. Tittle (no. 14), and John Henry Johnson (no. 35). Though together for only three years (1954–1956), each of the four players went on to be inducted into the Hall of Fame.

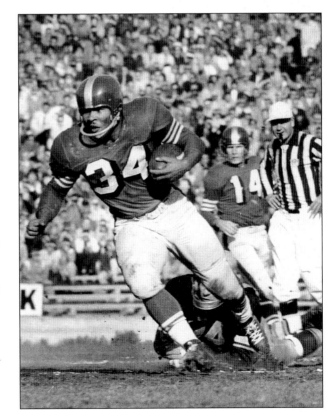

Fullback Joe Perry (no. 34) was a big part of the offense from the beginning. In his very first carry as a 49er in 1948 he ran 58 yards for a touchdown. Perry excelled as one of the greatest 49ers ever to play the game. If he was playing today, he could double for Emmit Smith with his similar style. Perry was extremely fast and had an explosive start once he got his hands on the ball.

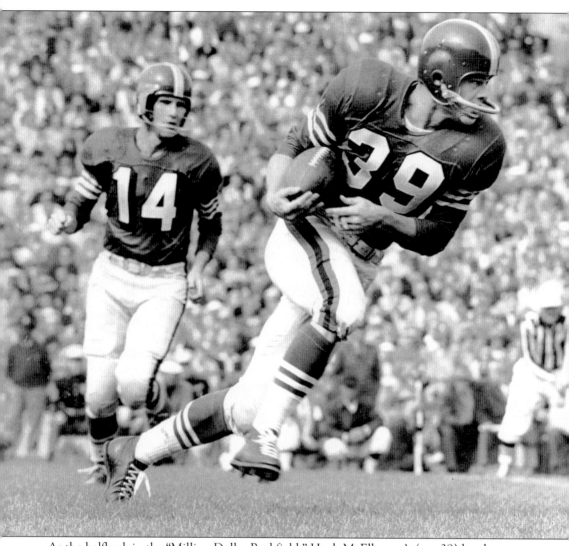

As the halfback in the "Million Dollar Backfield," Hugh McElhenny's (no. 39) breakaway runs were a thing of beauty. He could change directions quickly and still maintain his speed. It was Frankie Albert that gave McElhenny the name "King" after evidence of his touchdown run in his very first game as a 49er in 1952.

Fullback John Henry Johnson (no. 35) ran inside and outside with power, plus he was as fast as Perry and McElhenny. He was a perfect compliment to McElhenny's elusive moves, Perry's inside strength, and Tittle's passing arm. When the "Million Dollar Backfield" broke up in 1956, Johnson was traded away. In his brief 3-year career as a 49er, he accumulated 1,051 yards rushing, 12 touchdowns, and 40 receptions.

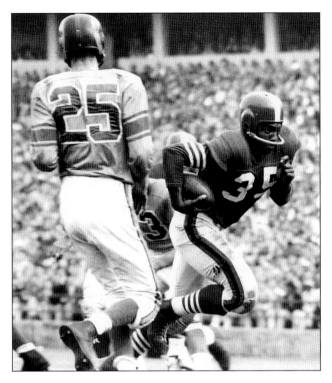

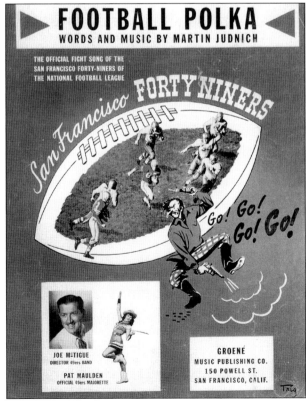

This is the official 49ers fight song ("Football Polka") sheet music. Martin Judnich wrote the words and music.

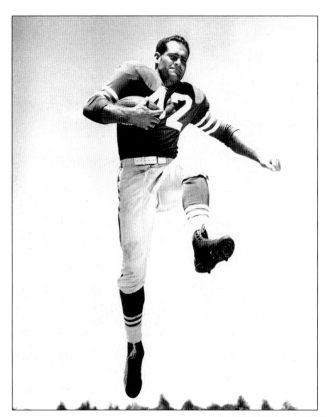

Halfback Lowell Wagner (no. 42), called "Slew Foot" by his teammates, was traded from the New York Yankees to the 49ers in 1949. The 6-foot, 195-pound Wagner made an immediate impact during the 49ers playoff game with the Yankees when he took an interception 65 yards for a touchdown in the 49ers 17-7 victory. In 1951, he led the team with nine interceptions and again in 1952 with six. As an alert, consistent defender, he played 6 years (1949–1953, 1955) for the 49ers and had 25 career interceptions.

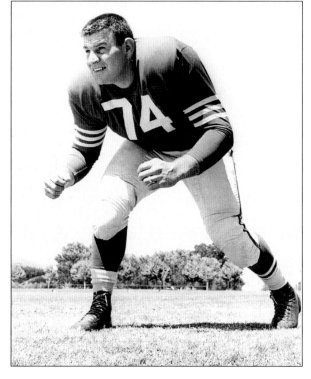

Bob Toneff (no. 74), 6 feet tall and 252 pounds, was an All-American at Notre Dame and played three positions for the 49ers—defensive tackle, linebacker, and guard. He was the fastest linemen on the team and was labeled a one-man wrecking crew" by his coaches. He was with the 49ers from 1952 to 1958 and played in 149 games.

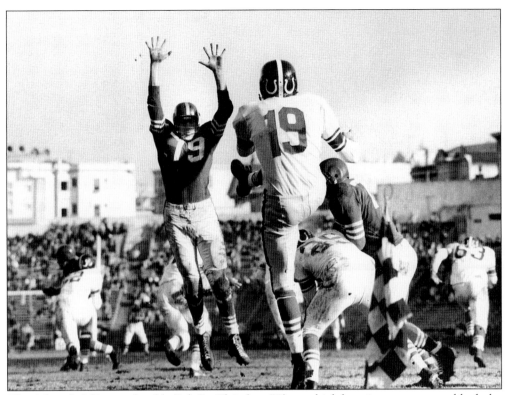

The 6-foot-9, 262-pound tackle Bob St. Clair (no. 79) goes high here in an attempt to block the Baltimore Colt's Ben Davidson's punt at Kezar for a 35-24 49ers win. In his career, St. Clair blocked 19 field goals and once lost five teeth blocking a punt. St. Clair was the 49ers offensive co-captain and earned All-Pro three times while making five Pro Bowl appearances. St. Clair was inducted into Hall of Fame in 1990.

Rams punt returner Cecil Turner receives a punishing blow tackle from 6-foot-3, 220-pound end Clay Matthews (no. 83),as tackle Bob Toneff (no. 74), end Charlie Powell (no. 87), and tackle Al Carapella (no. 75) are in pursuit during the 1955 home opener against the Rams at Kezar, won by the Rams 23-14.

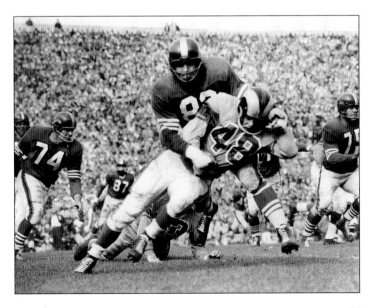

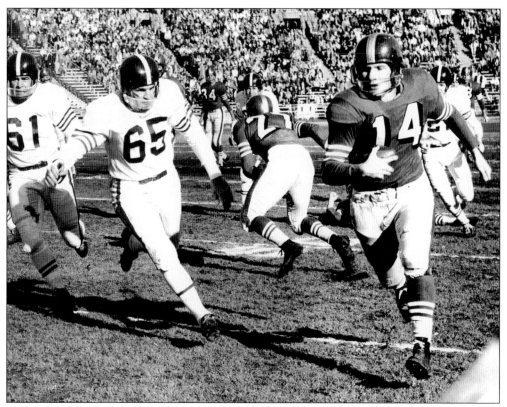

Quarterback Y.A. Tittle (no. 14) bootlegs the ball around end against the Baltimore Colts as Bill Coman (no. 65) and Jack Patera (no. 61), are in pursuit. R.C. Owens (no. 27) is the blocker in the background. This game was a 35-24 win at Kezar in 1955.

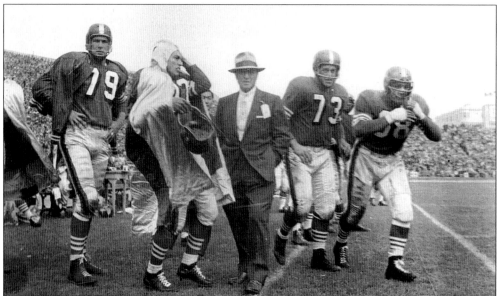

Tackle Bob St. Clair (no. 79), halfback Joe Arenas (in cape), head coach Norm Strader, tackle Leo Nomellini (no. 73), and guard Lou Palatella (no. 68) get ready to take the field at Kezar.

The 6-foot-1, 230-pound Lou Palatella (no. 68) was an outstanding guard and linebacker for the 49ers. At the University of Pittsburgh he received All-East honors in 1953–1954 and was named a Scholastic All-American. He played for the 49ers from 1955 to 1958.

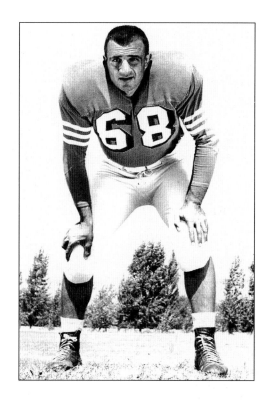

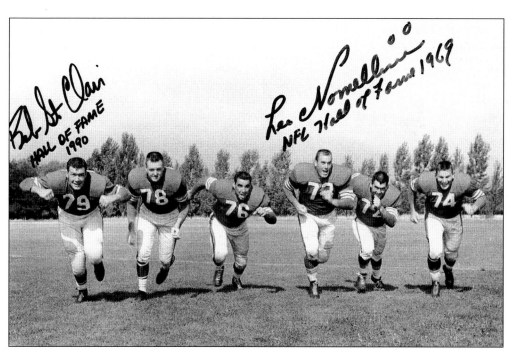

Tackle Bob St. Clair (no. 79), tackle Bob Cross (no. 78), guard John Gonzaga (no. 76), tackle Leo Nomellini (no. 73), tackle Bill Hershman (no. 72), and Bob Toneff (no. 74) practice wind sprints at the St. Mary's College training camp in 1956.

End Clyde Conner (no. 88) hauls in a pass thrown by Y.A. Tittle in a 28-17 preseason win over the Cleveland Browns in 1956. The 6-foot, 186-pound Conner was an outstanding pass receiver who played eight seasons for the 49ers (1956–1963), and had 203 receptions for 2,643 yards and 18 touchdowns.

The 6-foot-1, 234-pound Stan Sheriff (no. 50) played linebacker, guard, and center for the 49ers. He came from the Pittsburgh Steelers in 1956 and played through the 1958 season. Sheriff retired early to pursue a business career.

Halfback Joe Arenas gets his ankles taped up by head trainer Henry Schmidt as head coach Frankie Albert looks on in 1956.

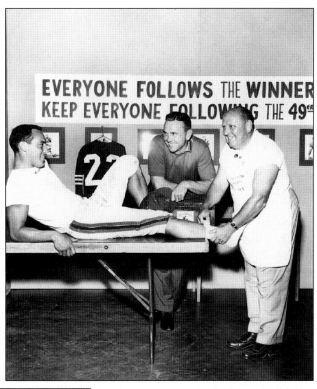

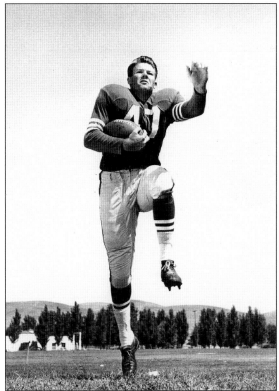

Halfback Dickey Moegle (no. 47) was drafted first overall by the 49ers in 1955. The 6-foot, 185-pound Moegle was an incredible running back at Rice University and scored five touchdowns in the Cotton Bowl. Moegle played both offense and defense for the 49ers, but was their starting defensive back in 1956. He led the team in interceptions in 1955, 1956, 1957, and ended up with a career total of 28. He was selected All-Pro in 1957–1958.

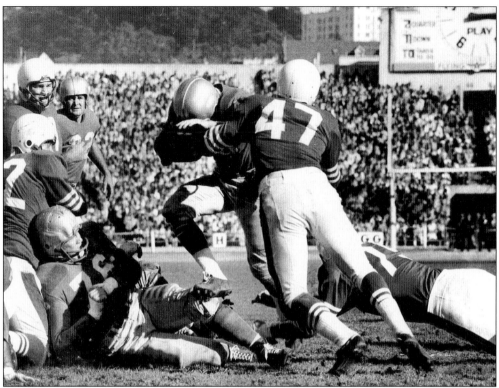

Defensive back Dickey Moegle (no. 47) puts the stop on Detroit Lions halfback Gene Gedman in a 1956 game played at Kezar and won by the Lions 17-13.

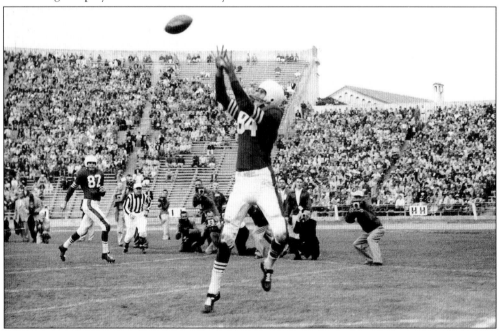

End Billy Wilson (no. 84) hauls in a touchdown pass thrown by Y.A. Tittle in a 1956 preseason game, won 14-13 against the Chicago Cardinals. Gordy Soltau (no. 82) looks on.

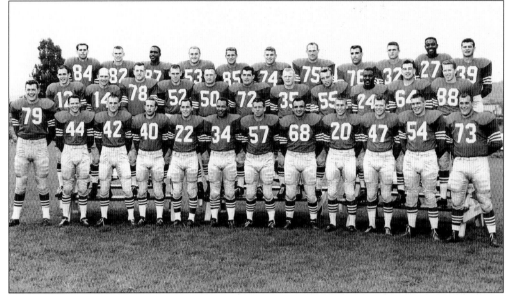

Pictured, from left to right, are the 1957 49ers: (front row) St. Clair, Walker, Ridlon, Holladay, Arenas, Perry, Carr, Palatella, Stits, Moegle, Matuzak, and Nomellini; (second row) Brodie, Tittle, Cross, Rubke, Sheriff, Herchman, Barnes, Hazeltine, Smith, Connolly, and Conner; (back row) Wilson, Soltau, Powell, Morze, Jessup, Toneff, Henke, Gonzaga, Babb, Owens, and McElhenny.

Assistant trainer Lincoln Kimura (left), Bob St. Clair (no. 79), Leo Nomellini (no. 73), and head trainer Henry "Smitty" Schmidt share some dialogue in the training room.

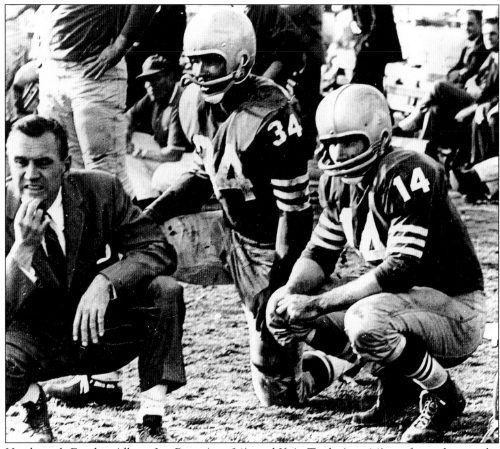

Head coach Frankie Albert, Joe Perry (no. 34), and Y.A. Tittle (no. 14) are focused in on the action from the sidelines during the 49ers–Green Bay Packers game (a 27-20 win over the Packers) played at Kezar in 1957.

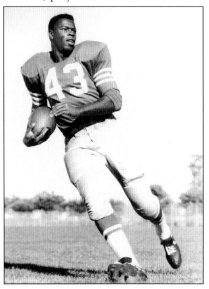

The 6-foot, 195-pound halfback Jimmy Pace (no. 43) was the first draft pick for the 49ers in 1958. He was highly recruited out of the University Michigan to play halfback for the 49ers and was expected to be the heir apparent to Hugh McElhenny. In 1958, he rushed for 162 yards and two touchdowns. In 1958, Pace's career was cut short by injuries and he retired.

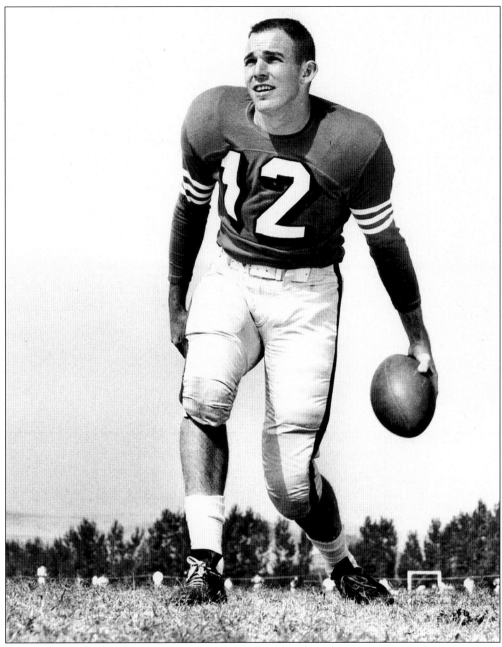

Quarterback John Brodie (no. 12) was probably the 49ers best pure passer during his career. The 6-foot-1, 195-pound Brodie was selected number one pick by the 49ers in 1957 and performed for 17 years (1957–1973). He led the 49ers to three Western Division titles in 1970, 1971, and 1973, but failed to win a championship. In his career he completed 2,469 passes for 31,548 yards, 214 touchdowns and rushed for 1,167 yards and 22 touchdowns. Brodie was selected All-Pro in 1965 and 1970, and also participated in the Pro Bowl in 1965 and 1970.

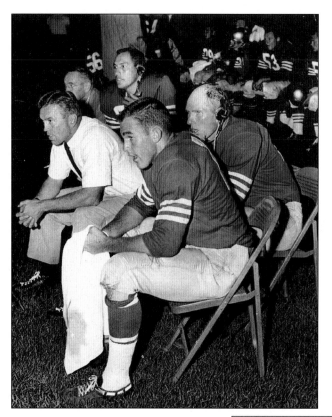

Pictured during halftime of the 1957 49ers-Chicago Cardinals preseason game in Seattle are, from left to right, head coach Frankie Albert, halfback Joe Arenas, and quarterbacks John Brodie and Y.A. Tittle.

Probably one of the finest defensive tackles and defensive ends for the 49ers was Charlie Krueger (no. 70). Drafted second overall in 1958, the 6-foot-4, 235-pound Krueger played for the 49ers for 15 seasons (1959–1973), and was a 2-time Pro Bowl selection (1960–1962). He received All-Pro recognition in 1960, 1965, and 1966. To honor Kruger's longevity and outstanding play, the 49ers retired his number in 1974.

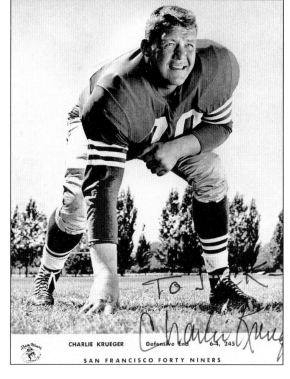

Disaster struck the 49ers in a 1958 preseason game against the Chicago Cardinals at Kezar when end Billy Wilson caught a touchdown pass from Y.A. Tittle, but landed on his shoulder causing a separation. Wilson missed the next eight weeks of the season. Here a disappointed head trainer Henry Schmidt, head coach Frankie Albert, and Billy Wilson are pictured.

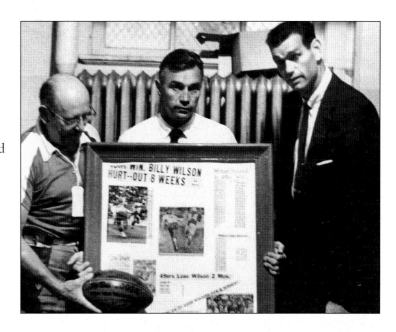

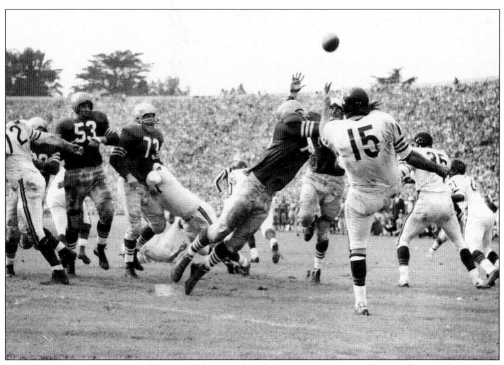

Tackle Bob Toneff (no. 74) comes close to blocking an Ed Brown (no. 15) punt during the 49ers 27-14 loss to the Chicago Bears at Kezar in 1958. Center Frank Morze (no. 53) and tackle Leo Nomellini (no. 73) are in the background.

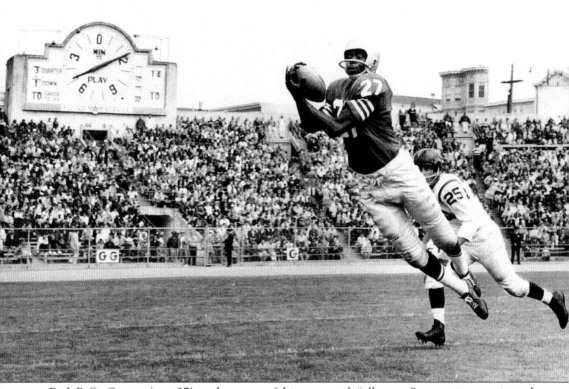

End R.C. Owens (no. 27) makes one of his patented "alley-oop" receptions against the Washington Redskins in 1957. The 49ers won the game 27-21. The 6-foot-3, 207-pound Owens used his tremendous jumping ability, developed during years of playing basketball, to spring up between defenders and grab the "blopper" ball thrown by Tittle. He played for the 49ers for 5 seasons (1957–1961) and recorded 206 receptions for 3,285 yards and 22 touchdowns.

The 49ers celebrated head coach Frankie Albert was featured on this "Men of America" Chesterfield cigarette ad during the 1957 season. The ad shows "live-action" shots of Albert and quarterback Y.A. Tittle at Kezar. The caption reads: "Check 'em out on every play—heads up—keep 'em driving all the way! Big pleasure coaching a winning team . . . It's Chesterfield!"

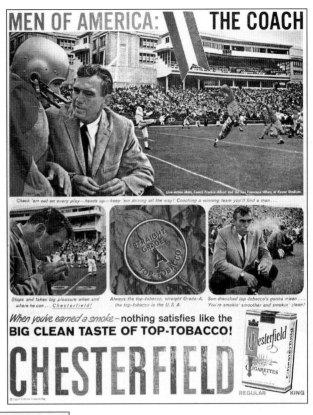

Here is the December 22, 1957 Western Division playoff game program. The 49ers earliest playoff appearance was against the Detroit Lions in that game. The 49ers had built up a commanding 27-7 lead on the Lions in the third quarter, but a furious fourth-quarter comeback enabled the Lions to win 31-27. Many 49er fans called this game, "a day in infamy" for the team.

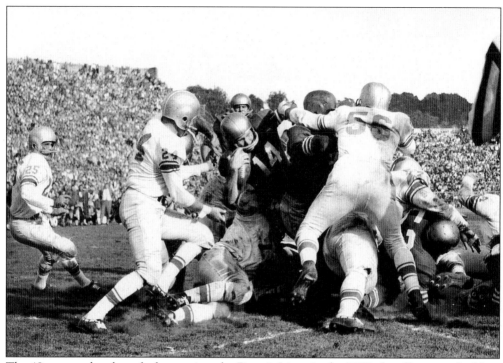

The 49ers scored early and often against the Detroit Lions in the 1957 playoff game to build up a big lead. Here Y.A. Tittle (no. 14) calls his own number with a quarterback sneak into the end zone for a touchdown.

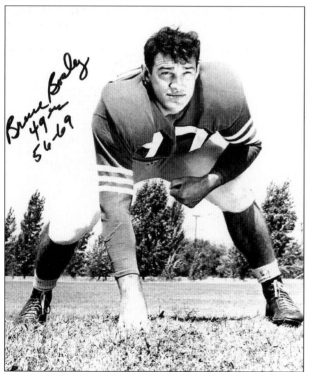

Bruce Bosely (no. 77), at 6-foot-2 and 237 pounds, established himself as one of the finest 49er guards and centers in team history. He began his career in 1956 as a defensive end, but made the shift to guard in 1957. His career spanned 14 years (1956–1969) as a 49er. He played in three Pro Bowls (1965–1967), and received All-Pro mention in 1959, 1960, and 1961.

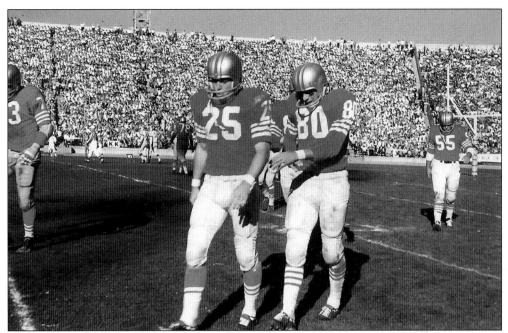

Defensive backs Dave Baker (no. 25) and Jerry Mertens (no. 80) established themselves as two of the best players of their time. Baker, a 6-foot, 190-pound number one draft pick of the 49ers in 1959, made an instant impression with 10 interceptions in 1960. He went to the Pro Bowl as a rookie and was a second team All-Pro three times (1959–1962). The hard-hitting, 6-foot, 197-pound Mertens came to the 49ers in 1958 as an unsung 20th round draft pick and immediately became a starter. Together, the Baker and Mertens duo solidified the 49ers secondary. Mertens played in 91 games during his 7-year career with the 49ers and recorded 8 interceptions.

Halfback J.D. Smith (no. 24) was a free agent who joined the 49ers and became a great running back and kickoff returner, rushing for 4,370 yards and scoring 46 touchdowns during his 9-year career (1956–1964) with the 49ers. The 6-foot-1, 209-pound Smith was All Pro in 1959–1961, 1962 and played in the 1959 and 1962 Pro Bowl. Smith was part of the "all-alphabet backfield" consisting of Y.A. Tittle, R.C. Owens, C.R. Roberts and J.D. Smith.

Two 49er Hall of Famers, Y.A. Tittle and Hugh McElhenny, ended their careers with the 49ers in 1960 and 1961 respectively. Tittle was traded to the New York Giants and McElhenny was let go in the expansion draft to the Minnesota Vikings. Both were reunited in 1963, but this time in the New York Giants backfield.

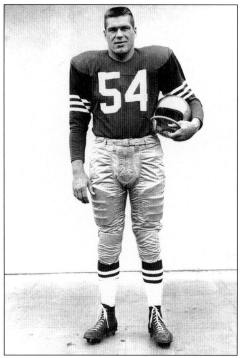

The 6-foot-3, 232-pound linebacker Marv Matuzak was acquired from the Pittsburgh Steelers in 1957 for quarterback Earl Morrall and guard Mike Sandusky. Matuszak was ranked among the league's best linebackers during the 1957 season and received All-Pro recognition and played in the Pro Bowl that year.

When the 49ers entered the NFL in 1950, the public relations department began sending out Christmas cards to their season-ticket holders. This one was sent out to 20,737 season-tickets holders.

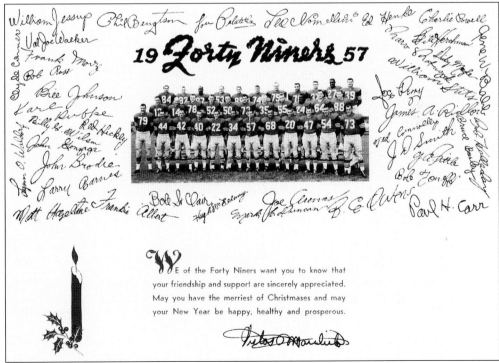

The foldout of the Christmas card usually portrayed a team photo with simulated autographs of all the team members and a greetings message signed by the owner.

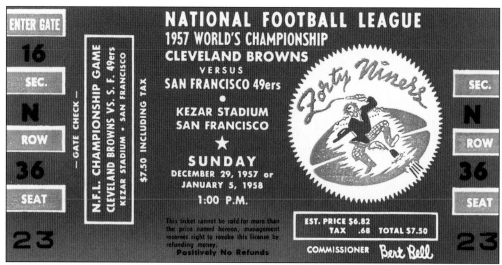

Sixty thousand tickets were prematurely printed up after halftime of a December 22 playoff game for the 1957 NFL Championship to take place December 29 at Kezar Stadium against the Cleveland Browns. However, the 49ers blew a 27-7 lead in the second half and lost 31-27 to the Detroit Lions for the Western Conference title. Almost a half-century later these unused tickets are now valuable collector's items, worth almost five times the amount of the their $57.50 cover price.

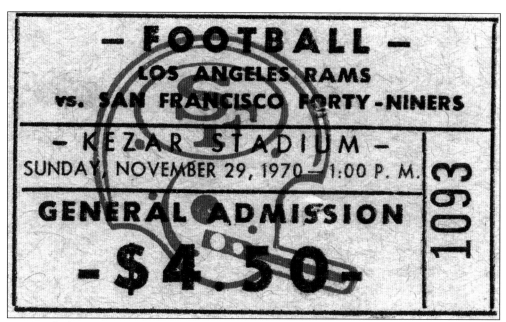

A general admission ticket allowed a patron into the 49er games at Kezar located at the east end zone. If the weather was clear, the sun would start setting above the west rim of the stadium and the glare would drive the fans crazy. It was from these sections that the "boo birds"—the 49ers avant-garde—would douse visiting players with beer or soda, and sometimes bottles, as they entered the stadium tunnel.

Four

The Roller Coaster Years

Not once did the team break into the postseason in the 1960s. Yet the decade was not without its memorable faces and moments. Midway through the 1960 season the 49ers were .500 after eight games and needed a boost. The inventive Hickey had Brodie and Tittle experiment with the new shotgun formation, where the quarterback stood five feet behind the center on snaps. Brodie seemed better able to thrive under this system, while Tittle, a drop-back passer, was uncomfortable with it. Still, the team won four of its last five games to finish in second place.

Optimism ran high after the season opener in 1961 when Brodie threw four touchdown passes in routing the Redskins 35-3 at Kezar. Quarterbacks Billy Killmer and Bobby Watters teamed up with Brodie in the shotgun and walloped the Lions 49-0. The following week they crushed the Rams 34-0. But Hickey's shotgun ended as abruptly as it began, once defenses figured it out. The 49ers went on to lose five out of their last eight games.

With most of the attention in 1962 riveted on the San Francisco baseball Giants, who were in the midst of a World Series with the Yankees, Hickey incurred his first losing season with the 49ers, when after three losing games into the 1963 season, he resigned. He was succeeded by Jack Christiansen, who also failed to turn the team around.

Brodie was the 49ers, for better or for worse. Many fans thought it was for worse, pointing to his high interception ratio (Brodie had 22 passes picked off in 1966 and 21 in 1968). Yet Brodie set a club record with 30 touchdowns in 1965, when the 49ers averaged 30 points a game, and in 1968 Brodie the third-highest-rated quarterback in the NFC. Brodie secured a $900,000 multi-year contract from the 49ers before the 1966 season, using an offer from the American Football League's (AFL) Houston Oilers to get a better deal with the 49ers.

During the 1964 season, owner Vic Morabito died of a heart attack, just like his older brother Tony had done seven years earlier. The wives of Victor and Tony Morabito, who retained control of the team, hired Lou Spadia as team president.

Fullback Ken Willard emerged as a starter his rookie year in 1965 and held the job for eight seasons from 1965 to 1971. His best year was 1968, when he had 967 yards rushing and 7 touchdowns.

On the defensive side, the 49ers were inconsistent through the 1960s. Linebackers Dave Wilcox, Frank Nunley, and cornerback Jimmy Johnson became stalwarts on defense, but the 49ers woes were typified in 1968 when the team was near the bottom of every defensive category. That season (when they finished 7-6-1), the 49ers were the third worst in the NFL in passing yardage allowed. Coach Christiansen was fired before the 1968 season and replaced by Dick Nolan, who ended the decade on a sour note as the 49ers went 4-8-2 in 1969.

Dick Nolan, the National Football Conference's (NFC) Coach of the Year, put together a team in 1970 that will be remembered for its grit and focus. The offensive line of guard Elmer Collett, tackle Len Rohde, and center Forrest Blue, protected Brodie better than ever, leading to only eight sacks all season. With more time Brodie threw 24 touchdowns and just 10 interceptions.

The defense was third best against the pass as defensive ends Cedric Hardman and Tommy Hart, and defensive back Bruce Taylor, NFC Player of the year, anchored the defense. In the last game of the regular season, needing a win or a tie to secure a Western Division title, the

49ers beat the Raiders 38-7. A week later Brodie led the 49ers to a 17-14 upset win over the favored Vikings.

Now NFC Champions—the first time in history—they played the Dallas Cowboys. The dream for the team's first Super Bowl berth ended here, as Dallas won 17-10.

After the season, the 49ers said good-bye to Kezar and moved to Candlestick Park. In 1971, the 49ers won another Western Division Championship. Needing to beat the Lions in the last game of the season, the 49ers came from behind to win 31-27. The 49ers won their playoff game with the Redskins 24-20, but again the 49ers lost in the NFC Championship game in Dallas, 14-3.

The 49ers were back again in the playoffs in 1972. Again they needed to win the season's last game to capture the West. They did it in dramatic fashion. Brodie sparked a fourth-quarter rally against the Vikings, and with little time left to play threw a touchdown pass to receiver Dick Witcher for the game winner. Next up were the Cowboys again for the NFC West title. And once again, for the third time in a row, the Cowboys won by a score of 30-28.

The 49ers were never the same again and followed with three straight losing seasons. Brodie retired in 1973, and it was also the last season for Ken Willard and Charlie Krueger.

1974 was an obvious rebuilding year for the 49ers. After winning their first two games they lost seven in a row. Still, their 5-9 record was good enough for second place in the weak NFC West. Running back Wilbur Jackson was named *Sporting News* Rookie of the Year.

Before the start of the 1976 campaign, Monte Clark, who brought in quarterback Jim Plunkett from the Patriots for four draft picks, replaced Dick Nolan. Still, the 49ers struggled, but managed to finish 8-6 for their first winning season since 1972.

Monte Clark resigned in 1977 and a new owner emerged to run this failing franchise—Eddie DeBartolo Jr. of Youngstown, Ohio. DeBartolo then hired Joe Thomas as general manager, and Ken Meyer was hired as head coach.

With Meyer coaching, the 49ers dropped their first five games in 1977. Ultimately, Thomas fired Meyer and the entire coaching staff and Pete McCulley was brought in to coach the team. But after the 49ers lost eight of their first nine games in 1978, McCulley was fired and Fred O'Connor was named coach. The team finished a dismal 2-14.

1979 saw even more upheaval as DeBartolo fired Thomas, brought in Bill Walsh from Stanford to be coach and general manager, and named Carmen Policy president of the team. In Walsh's first college draft, he chose quarterback Joe Montana and tight end Dwight Clark. Neither played much his rookie year, and Walsh finished up with a 2-14 record, but he effectively turned the offense around with Steve DeBerg at quarterback for much of the season. Some other good things happened late in the season as Joe Montana emerged as the starting quarterback on his way to becoming the best in the game. Behind Montana, the 49ers won three of their last five games, an encouraging sign for the future.

74

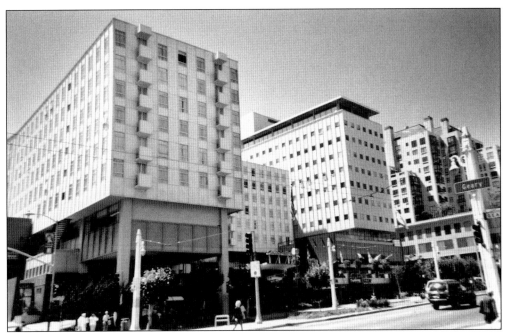

The Jack Tar Hotel at Geary and Van Ness in San Francisco served as 49er headquarters from 1960 to 1976. Other team headquarters' locations were 212 Stockton Street (1946–1949) and 760 Market Street (Phelan Building) in San Francisco; 711 Nevada Street, Redwood City (1977–1987); and currently 4949 Centennial Boulevard in Santa Clara (1998–2004).

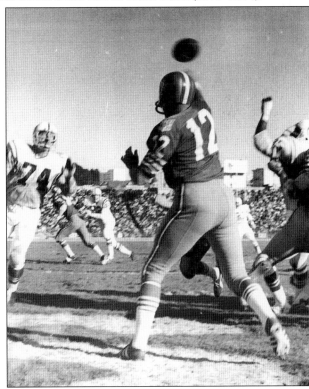

Quarterback John Brodie (no. 12) throws the ball downfield against the Baltimore Colts in a 49ers win at Kezar 34-10. Brodie ended the day with 10 completions in 24 attempts for 99 yards and 1 touchdown. In 1960 the 49ers finished with a 7-5 record after winning four of their last five games under Head Coach Red Hickey.

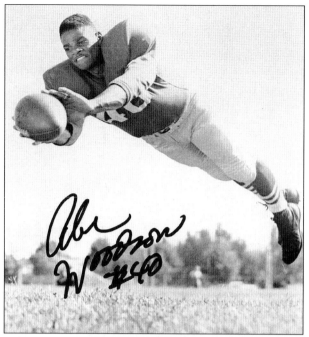

Versatile halfback Abe Woodson (no. 40) was the 49ers number two draft pick in 1957. The 5-foot-11, 188-pound Woodson was a quintuple-threat with 4,873 yards returning kickoffs, 949 yards returning punts, 159 yards returning interceptions, 74 yards receiving, and 39 yards rushing. He holds four of the five longest kickoff returns in 49ers history and was selected All-Pro from 1959 to 1963.

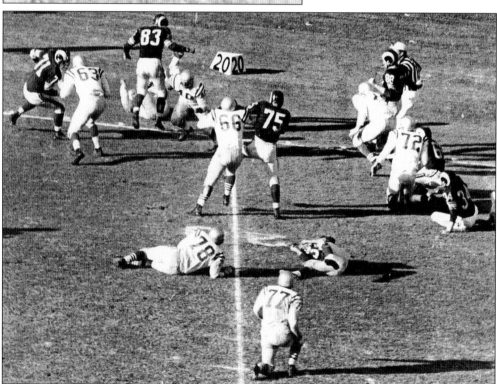

Abe Woodson heads up field between blocks by tackle Monte Clark (no. 63) and guards John Wittenborn (no. 66) and Bill Hershman (no. 72) on his way to a record 105-yard kickoff return for a touchdown against the Los Angeles Rams in 1959. Tackle John Thomas (no. 78) and center Bruce Bosely (no. 77) are in the foreground.

The 49er public relations department began sending out monthly newsletters called the "49ers Diggings" in the off-season to season-ticket holders beginning in 1953, and it continued through the 1970s. These six-page newsletters offered information such as a team schedule, roster, statistics, features on draft picks, and in-depth reviews of the up-coming season.

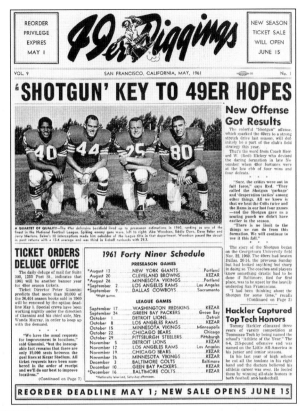

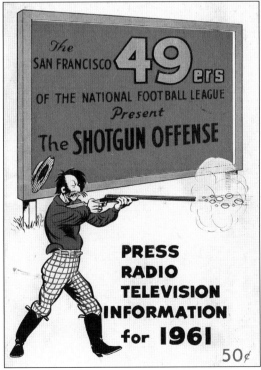

The 49ers media guide was produced from its inception in 1946. Filled with 35 pages of player profiles and statistics, game results, season reviews and historical information, these guides could be purchased directly from the franchise.

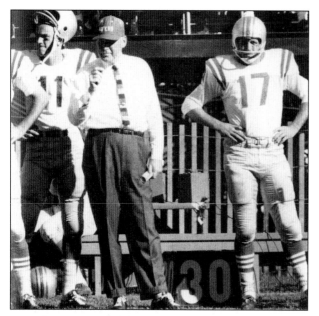

Three key figures of the "shotgun formation" pictured here are quarterbacks Bobby Waters (no. 11), Billy Kilmer (no. 17), and Head Coach Red Hickey, the architect of the shotgun formation. In 1960, Hickey saved a seemingly hopeless season when he installed the shotgun attack and the club started winning. Kilmer, at 6 feet and 204 pounds, was a quarterback who ran for 987 yards, scored 15 touchdowns, and passed for 477 yards from the shotgun. Bobby Waters, at 6-foot-2 and 184 pounds, ran for 477 yards and 3 touchdowns.

Cartoonists Lee Sussman, Dunn & Thompson, and Hal Allen featured humor in their illustrated cartoons before 49er games in local San Francisco throughout the 1950s and 1960s. They usually portrayed a game theme expressing mirth at the 49ers' opponent.

The 6-foot-4, 215-pound Bernie Casey (no. 30) goes up high to snag a pass thrown by John Brodie in a 1962 game against the New York Giants at Kezar. The 49ers won 42-10. Casey, a big, fast, graceful receiver, teamed with John Brodie during his 6 seasons (1961–1966) for 277 catches, 4,008 yards, and 27 touchdowns with the 49ers.

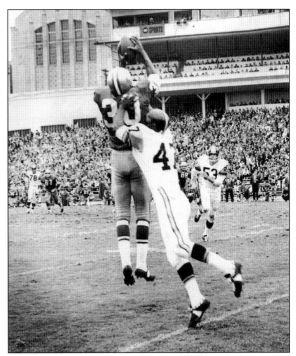

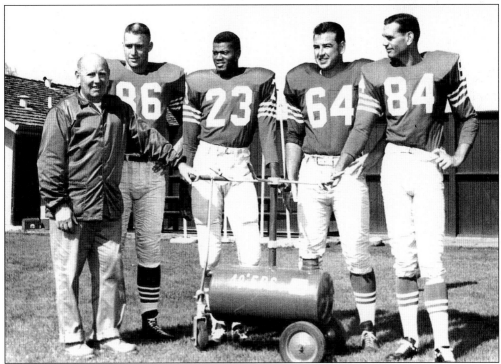

Trainer Henry Schmidt, defensive end Don Colchico (no. 86), halfback Ray Norton (no. 23), guard Ted Connolly (no. 64), and end Billy Wilson (no. 84) gather during training camp. Norton, a speedster, was drafted as a halfback in 1960 with great potential, having participated in the Olympic games in Rome.

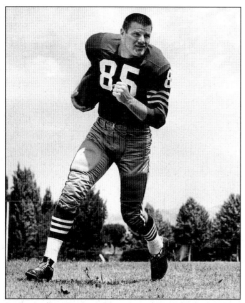

Monty Stickles (no. 85) was a premier tight end for the 49ers. He used his 6-foot-3, 230-pound bulk to wreak havoc on his opponents. During his 8-year career (1960–1967) with the 49ers, Stickles caught 207 passes for 2,993 yards and 14 touchdowns.

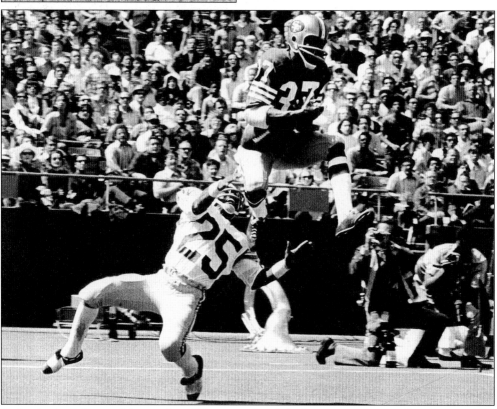

Defensive back Jimmy Johnson (no. 37) is considered the best cover man in 49ers history. The 6-foot-2, 187-pound Johnson was 7 times All-Pro, played in 5 Pro Bowls, and won the Len Eshmont award twice (1969 and 1974) for his "inspirational and courageous play." During his 16-year career (1961–1976) he had 47 interceptions and 7 touchdowns. Johnson was inducted into the Hall of Fame in 1994.

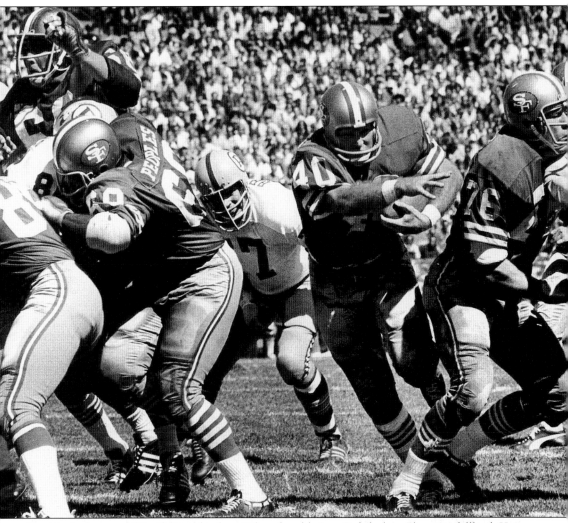

Key blocks by guard Woody Peoples (no. 69) and tackle Len Rohde (no. 7) spring fullback Ken Willard (no. 40) for a short gain against the Washington Redskins at Kezar. The 1969 game ended in a 17-17 tie. The 6-foot-2, 230-pound Willard was an outstanding fullback for the 49ers who led the team in rushing for 7 straight years (1965–1971). He is the third all-time in rushing for the 49ers with 5,930 yards. He was a member of the 1970, 1971,and 1972 playoff teams, and appeared in four Pro Bowls, receiving "honorable mention" three times as All-Pro.

As a third-round draft pick in 1964, Dave Wilcox (no. 64), nicknamed "The Intimidator" by his coaches for his tough, hard-nosed playing style, established himself as the best linebacker in the history of the franchise. The 6-foot-3, 241-pound Wilcox teamed up with defensive back Jimmy Johnson to shut down the left side of the defense and intimidate most tight ends. He had his best season as a pro in 1973, recording 104 tackles, 13 for losses, forcing 4 fumbles, and recovering 1. He earned seven Pro Bowl nominations and was a seven-time All-Pro selection.

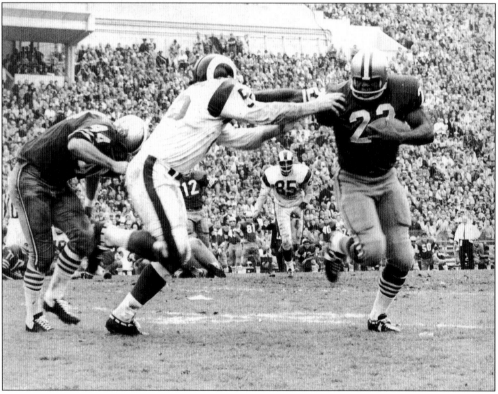

The 6-foot-3, 225-pound halfback Gary Lewis (no. 22) picks up good yardage against the Los Angeles Rams as running back John David Crow (no. 44) attempts to block in a 30-27 win over the Rams in 1965. The multi-talented Lewis played for the 49ers from 1964 to 1970, rushing for 1,421 yards and scoring 13 touchdowns, while catching 72 passes for 604 yards. Lewis was also an excellent kickoff returner.

Defensive back Kermit Alexander (no. 39) was a first-round pick by the 49ers in 1963 and led the team with 5 interceptions and averaged 26.6 yards on 24 kickoff returns. From 1963 to 1969, playing opposite cornerback Jimmy Johnson, the 5-foot-11, 180-pound Alexander accumulated 36 interceptions and led the team in punt returns 5 times (1964–1968) while being chosen All Pro and to the Pro Bowl in 1968.

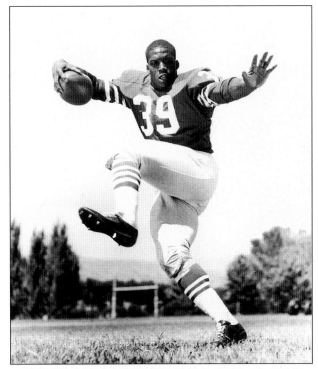

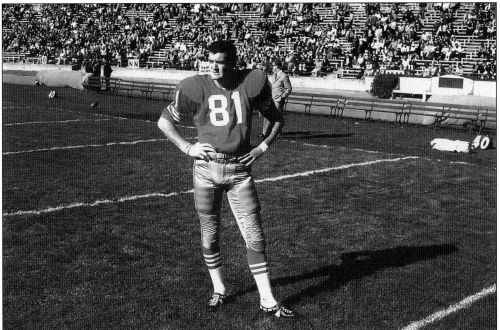

End David Parks (no. 81) was the 49ers first-round pick in 1964. At 6-foot-2, 207 pounds, he had blazing speed and was a tremendous deep threat for the 49ers. As a rookie he caught one 79- and two 83-yard touchdown passes from John Brodie. In 1965 he led the NFL with 80 catches and 12 touchdowns. He went to the Pro Bowl in 1964–1965 and was chosen All-Pro three times (1964–1966).

One of the most durable 49ers ever to play running back was running back John David Crow (no. 44). In 1964 alone, the 6-foot-2, 224-pound Crow rushed and caught passes for 1,031 yards and 9 touchdowns. During his career (1965–1968) his totals were 2,195 yards rushing and 19 touchdowns scored, and an incredible 258 catches for 2,195 yards and 18 touchdowns.

In this 20-20 tie game in 1968, halfback Bill Tucker (no. 45) dives in for a touchdown against the Los Angeles Rams as guard Woody Peoples (no. 69) lays a crushing block. Tucker, a 6-foot-2, 232-pound, third-round draft pick was a durable ball carrier for the 49ers. During his 4-year career (1967–1970) he rushed for 431 yards, 6 touchdowns, and caught 59 passes for 496 yards, including 7 touchdowns.

The 6-foot-5, 245-pound defensive end Clark Miller (no. 74) had great quickness and speed at his position. He was an invaluable starter for 7 straight seasons, playing in all 97 games for the 49ers. An example of Miller's quickness came on a November 14, 1965 away game against the Detroit Lions when he scooped up a fumble and outran all the Lions defenders for a 75-yard touchdown.

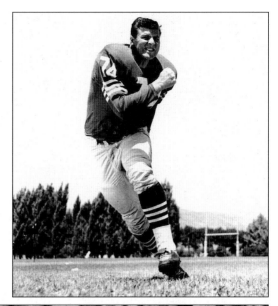

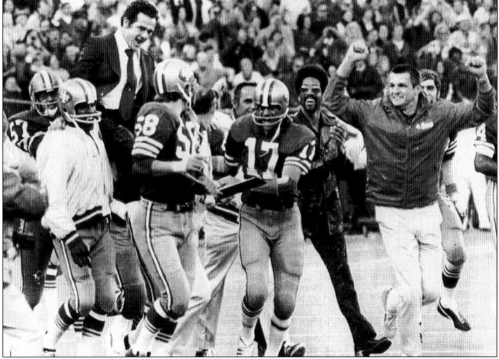

Head coach Dick Nolan is carried off the field by his 49ers players as they celebrate their second NFC Western Division title in 1971 after beating the Detroit Lions 31-27 at Kezar. Nolan arrived in 1968 and was responsible for rebuilding the 49ers into contenders. He brought the "flex" defense and an enthusiasm that produced the most successful stretch in the team's first three decades with back-to-back NFC West titles from 1970 to 1972. In 1970, Nolan was NFC Coach of the Year as his offensive line gave up only eight sacks all season. Yet he lost his chance at greatness by losing three straight playoff games to the Dallas Cowboys (1970–1973). From 1968 to 1975, Nolan won 69 games, lost 82, and tied 5 times. His playoff record was 2-3.

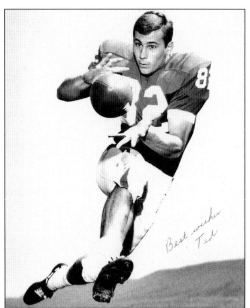

Tight end Ted Kwalick (no. 82) was the 49ers first-round pick in 1969. He was the starter on the NFC West Championship teams from 1970 to 1972, and played superbly during his career with the 49ers (1969–1974). The 6-foot-4, 219-pound Kwalick led the team 3 straight years in receiving (1971–1973) with 139 receptions for 2,144 yards and 19 touchdowns. He played in the three Pro Bowls (1971–1973), and was selected All-Pro three times in those same years.

End Clifton McNeil (no. 85) picks up 17 yards after catching a John Brodie pass in a 27-20 49ers win over the Green Bay Packers at Kezar in 1968. McNeil, at 6-feet-2 and 187 pounds, was a deep threat traded to the 49ers from the Cleveland Browns for a second-round pick and contributed instantly to the receiving corps, leading the team with 71 receptions for 994 yards and 7 touchdowns in 1968.

This is a shot of the 49ers-Raiders September 3, 1967 preseason game program. It was the first contest between the two Northern California teams, and was played before 53,000 spectators, the first sellout in Oakland-Alemeda County Coliseum's history. Over the years, these two teams have rekindled a rivalry much like the 49ers and Los Angeles Rams had before the Rams moved to St. Louis in 1995.

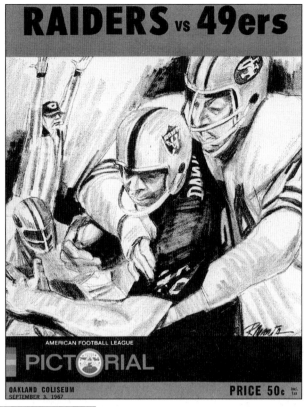

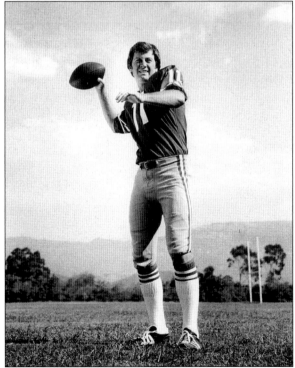

Heisman Trophy winner and quarterback Steve Spurrier (no. 11) was a first-round pick out of the University of Florida. The 6-foot-1, 200-pound Spurrier never quite lived up to the 49ers expectations, but proved to be a valuable asset during the 1972 season when he replaced the injured John Brodie and guided the 49ers to the playoffs. During his 9-year career with the 49ers he completed 441 passes for 5,200 yards and 33 touchdowns.

End Gene Washington (no. 18) goes out of bounds after catching a pass against the San Diego Chargers in a 1971 preseason game that the 49ers won 28-17. Washington, at 6-foot-1 and 185 pounds, and a first-round draft pick in 1969, was converted from quarterback to wide receiver his rookie year. He made it to the Pro Bowl that year and for the next three seasons before becoming All-Pro three times (1970–1972). Washington is ranked seventh all-time in receptions as a 49er with 371 catches for 6,664 yards and 59 touchdowns.

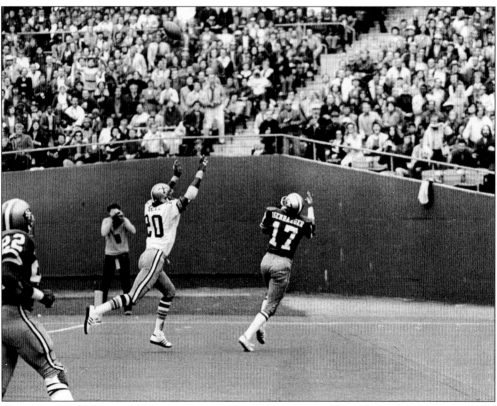

The 6-foot-3, 205-pound John Isenbarger (no. 17) catches a 33-yard touchdown pass in the 49ers 40-0 win against the New Orleans Saints at Kezar in 1973. Isenbarger played halfback as a spot player, but was a viable asset to the team with his speed and quickness. In his 4-year career with the 49ers (1970–1973), he rushed for 80 yards and caught 21 passes for 291 yards and 2 touchdowns.

End Danny Abramowicz, (no. 46) came to the 49ers in 1973 after an illustrious seven-year career with the New Orleans Saints. Though he played sparingly in his two-year (1973–1974) tenure with the 49ers, he made an immediate impact. In 1973 he played in all 14 games with 37 receptions for 460 yards and 1 touchdown. The 6-foot-1, 195-pound Abramowicz closed out his career with 25 receptions, 369 yards, and a touchdown in 1974.

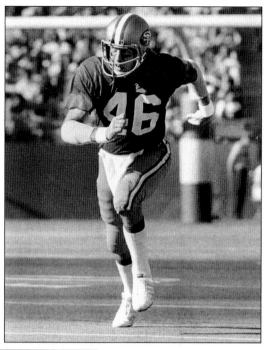

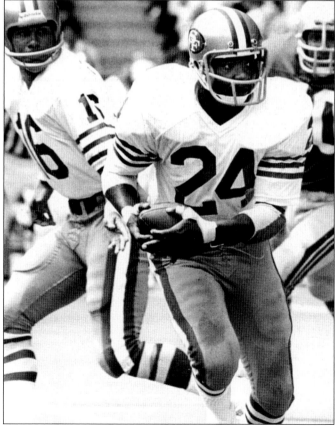

The durable 6-foot, 195-pound halfback Delvin Williams (no. 24) takes a handoff from quarterback Jim Plunkett (no. 16) in this 1977 photo. Williams played admirably during his four-year career (1974–1977) with the 49ers and was selected to the 1974 Pro Bowl. Altogether, Williams played in 54 games, gained 2,632 yards, scored 20 touchdowns rushing, and had 84 receptions for 5 touchdowns.

Halfback Paul Hoffer (no. 36) climbs over the top of the Rams defense for a short gain in the 49ers 26-20 loss at Kezar in 1979. The 6-foot, 195-pound Hoffer was a superb running back and kickoff return man with the 49ers from 1976 to 1981. He showed flashes of brilliance with his open-field running, much like the style of Hugh McElhenny from the 1950s, but an injury cut short his career. His career totals were 1,746 yards rushing and 16 touchdowns rushing, and 1,474 yards, and a 21.7 average on his kickoff returns.

Halfback O.J. Simpson (no. 32) was called "The Juice," but his career with the 49ers was marred by a knee injury that hampered his production, as his best days were behind him by then. To get Simpson, the 49ers gave up a first-round draft pick, two second-round picks, as well as third- and fourth-round picks to the Buffalo Bills. The 6-foot-1, 212-pound Simpson played just 2 seasons with the 49ers (1978–1979) and gained 1,053 yards rushing (averaging just 3.7 yards a carry) before retiring.

FIVE
The Super Bowl Era

In their second season of the Bill Walsh era (1980), the 49ers showed gradual improvement in their rebuilding program. A defining moment for this team, as far as character goes, came in week 14 of the season when the 49ers overcame a 35-7 New Orleans Saint deficit to win in overtime, 38-35.

Their 6-10 record was overshadowed by an offense that was on the rise. Montana set a club passing percentage with .645, and tight end Dwight Clark caught 82 passes to break the team receiver mark, while another rookie fullback Earl Cooper led the NFC in total receptions with 83.

The 49ers strengthened their defense in 1981 through the draft selecting defensive backs Ronnie Lott, Eric Wright, and Carlton Williamson, who all stepped into immediate starting roles. Linebacker Jack Reynolds was obtained from the Rams and defensive end Fred Dean from the Chargers, and both contributed greatly during the team's Super Bowl run.

After a 2-3 start, the 49ers won 10 of their remaining 11 games, humiliating the Dallas Cowboys along the way, 45-14. The 49ers won the NFC West, and then knocked out the New York Giants in the first round. A rematch with the Cowboys was next and
the 49ers won in dramatic fashion, 28-27 on a Montana-Dwight Clark pass and catch with 58 seconds to play. The 49ers would meet the Cincinnati Bengals in Super Bowl XVI, after posting an incredible 15-3 season.

In the game, the 49ers built up a 20-0 halftime lead, but in the end it took a dramatic goal-line stand to preserve a 26-21 victory. It was the 49ers first Super Bowl win in their 35-year team history.

In 1982, the defending world champion 49ers fell to 3-6 and missed out on the playoffs in a strike-shortened season. They failed to win a home game for the first time in the history of the franchise, though Dwight Clark had an outstanding season, leading the NFL with 60 receptions, and tackle Keith Fahnhorst was selected to the All-Pro team.

The 49ers returned to their winning ways in 1983, and made it to the NFC Championship game. Rookie running back Roger Craig became an instant success and teamed with running back Wendel Tyler, who had been acquired from the Rams for two draft picks.

The 49ers lost the season opener to the Eagles, but came back to win four of their next five games. In the last game of the season, the 49ers clinched a playoff berth ripping the Cowboys 42-17. They squeezed by the Lions in the playoffs, but lost the NFC title game to the Washington Redskins and failed to repeat as Super Bowl champions.

It took some years, but finally the pieces were in place. With all the players experienced with the Bill Walsh West Coast Offense, the 1984 49er offense operated at peak efficiency. On defense, coordinator George Seifert did a masterful job of coming up with an innovative dominating scheme.

The 49ers won 15 regular season games, including all 8 road games, setting an NFL record. They beat the New York Giants in the first round of the playoffs, followed by whipping the Chicago Bears 24-0 before the largest Candlestick crowd ever of 61,050. They capped the year with a dominant 38-16 victory over the Miami Dolphins in Super Bowl XIX. The 49ers broke

14 team records in 1984. Led by Joe Montana and Roger Craig, they scored a team-record 475 points, while the defense gave up only 227 points to lead the NFL.

The nucleus of the team was virtually unchanged in 1985, except for the arrival of rookie wide receiver Jerry Rice, the team's first-round draft pick. The 49ers finished 10-6 and entered postseason play for the fourth time since 1981. Rice emerged as a potent weapon, while Craig became the first NFL player to surpass 1,000 yards rushing and receiving in the same season. But injuries mounted during the season and into the playoffs. At New York, the Giants humbled the 49ers 17-3. They failed to score a touchdown for the first time in their playoff history.

Still the 49ers captured their fourth NFC Western Division title in 1986 with a 10-5-1 record, but it wasn't easy. Montana missed three exhibition games due to a herniated disk that required surgery. It was speculated Montana would be out for the season, but Montana returned after 13 weeks to spark the 49ers to a 43-17 win over the Cardinals. The 49ers failed to advance in the playoffs, as once again Montana was knocked out of the game and the Giants beat the 49ers convincingly, 49-3.

San Francisco started off the 1987 season with a bang, winning seven of their first eight games. They marched to an NFL regular season best 13-2 record, and then capped the season with a blowout of the Rams 48-0 in the season's final game. Though the 49ers entered the playoffs as prohibitive favorite against the Minnesota Vikings, they were upset 38-24. For the season, the 49ers accumulated 5,987 yards of total offense (a team record) and appeared unstoppable. Rice set an NFL record with 22 touchdowns and MVP recognition, while Montana set a team record with 31 touchdown passes.

Montana survived a quarterback controversy with Steve Young at the start of the 1988 season and led the 49ers to a 13-6 record while winning the NFC West. In the playoffs, the 49ers avenged their playoff loss in 1987 with a 34-9 drubbing of the Vikings. Then the Chicago Bears were defeated 28-3 in the NFC Championship game. The climax of the season came with a dramatic touchdown in Super Bowl XXIII to beat the Bengals 20-16. Montana's 10-yard scoring pass to wide receiver John Taylor with 34 seconds remaining gave the 49ers their third Super Bowl win of the decade, and rights to the title "Team of the 80s." Roger Craig broke the 49ers single-season rushing record with 1,502 yards. Rice won the Super Bowl MVP award with 11 receptions and a Super Bowl record of 215 yards.

After winning their third World Championship Bill Walsh retired, and George Seifert was named head coach. In his first season at the helm, Seifert guided the 49ers to a 17-2 record and a repeat as world champions. During the season, the 49ers displayed optimal performance at the highest level with a resounding 55-10 defeat of the Denver Broncos in Super Bowl XXIV.

The 49ers tied or set nearly 40 Super Bowl records, and Montana was the game's MVP for the unprecedented third time. Montana had the best season of his 11-year career. By setting an NFL season record with a 112.4 quarterback rating and was the recipient of the Len Eshmont Award, given annually to the 49er who best exemplifies courageous and inspirational play, while tackle Michael Carter was selected All-Pro for the third straight season.

For the decade, the 49ers established themselves as the most dominant NFL team ever, winning 117 games.

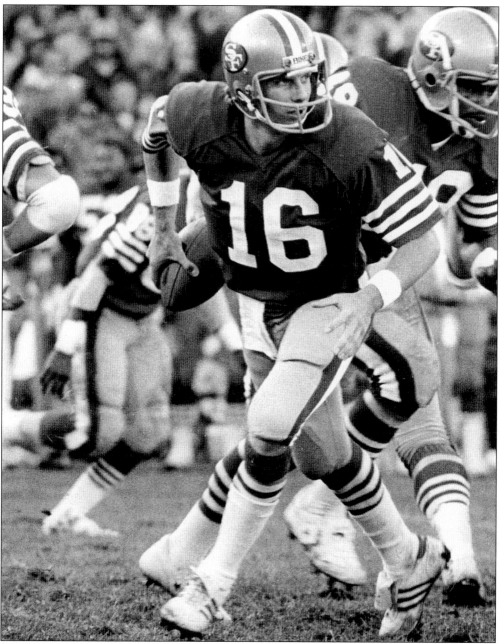

Quarterback Joe Montana (no. 16) is the one player who personifies the 49er destiny and is one of the most legendary figures in its history, as his four Super Bowl rings and two NFL MVP trophies represent. Nobody was better in the clutch than Joe "cool" and he became the symbol of the 49ers being known as "the team of the 80s." Montana's 35,124 yards passing (he rushed for 1,595 yards) easily makes him the most prolific yardage producer in 49ers history. The 6-foot-2, 200-pound signal caller finished his career with 273 touchdowns and ranks second all-time with a 92.3 passing rating and a 62.3 completion percentage. During his 16-year career (1979–1994) he appeared in 8 Pro Bowls (1981, 1883–1990), and was All-Pro in 1981, 1985, 1987, 1989–1990. He was inducted into the Hall of Fame in 2000.

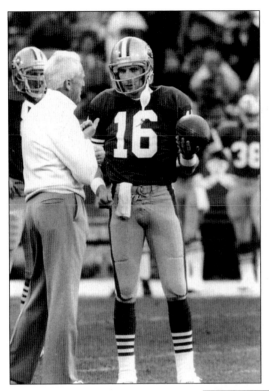

Quarterback Joe Montana (no. 16) takes advice from Head Coach Bill Walsh on the sidelines. It was Walsh who turned the franchise into three-time Super Bowl Champions, doing it with dignity and class. He was considered an "offensive genius" and creator of his innovative West Coast Offense. He coached the 49ers from 1979 to 1988, and combined a .617 winning percentage with a 102-63-1 mark that included 10 wins in 14 postseason games. He was named NFL Coach of the Year in 1981 and 1984. Walsh also served as the club's general manager and team president, and is a member of the NFL Hall of Fame.

The 6-foot-3, 205-pound Dwight Clark (no. 87) was an outstanding tight end who will always be known for "The Catch" he made in the 1981 championship game to beat the Dallas Cowboys. During his 9-year career (1979–1986) Clark finished with 506 receptions for 6,750 yards receiving and 48 touchdowns. Clark ranks third on the 49ers all-time reception list and second in receiving yards. He was honored with the Len Eshmont award and was selected as All-Pro in 1982. In his honor, the 49ers retired his jersey number in 1988.

Owner Eddie DeBartolo Jr. is the first to congratulate quarterback Joe Montana (no. 16) after his last-minute heroics against the Dallas Cowboys in the 1981 NFC Championship game. DeBartolo loved his players and did everything possible for the team. The five-time world champion owner was in charge from 1977 to 1997, and his philosophy was simple—spend whatever it cost to keep the 49ers at the top of the NFL.

Center Randy Cross (no. 51) was probably the best player ever at his position in the history of the franchise with his speed and power. The 6-foot-3, 259-pound Cross was the starting center for the 1981, 1984, and 1988 Super Bowl teams. He received All-Pro recognition in 1980–1981, 1984–1985, 1986, and 1988, and he played in three Pro Bowls in 1981, 1982, and 1984.

Defensive end Fred Dean (no. 74) came to the 49ers via a trade with the San Diego Chargers and made an immediate impact with the team. At 6-foot-3 and 230 pounds, Dean's speed and quickness was impeccable. In the 1981 Super Bowl season, he was chosen UPI Player of the Year, made All-Pro, and went to the Pro Bowl. Dean played from 1981 to 1985, and had 40 sacks with a team high 17.5 in 1983.

Wide receiver Jerry Rice (no. 80) stretches to catch a pass from quarterback Joe Montana against the Cleveland Browns. Rice, 6-foot-2, 196 pounds, called "Flash 80" by his teammates, is the greatest receiver in NFL history. His conditioning and work ethic helped break numerous 49er receiving records: he was the first player to score 176 touchdowns (including 10 rushing); was the career leader in receptions (1,251) and yards from scrimmage (19,274); had consecutive games with at least one catch (225); and he had the most seasons with 1,000 or more yards (12). Rice was selected All-Pro 11 times (1986–1998), and played in the Pro Bowl 12 times 1986–1996 and 1998 as a 49er.

The 49ers defensive ends Jim Stuckey (no. 79) and Jimmy Webb (no. 74) and tackles Archie Reese (no. 78) and Ted Vincent (no. 75) get ready to clash heads with the Oakland Raiders offense in a preseason game played at Candlestick Park in 1980. The 49ers prevailed over their Bay Area archrivals 33-14, and finished the preseason with a respectable 3-1 record.

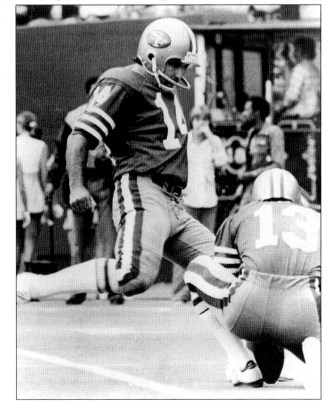

Place kicker Ray Wersching (no. 14) was the team scoring leader between 1978 and 1986 and ranks second on the all-time scoring list in 49ers history. His longest field goal was 53 yards against the Detroit Lions in 1984. In his 11-year career (1977–1987) with the 49ers, Wersching connected on 192 field goals and 409 PAT's (Point After Touchdown) for a total of 979 points.

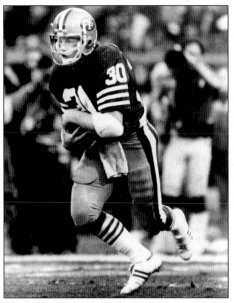

Running back Bill Ring (no. 30) was a key spot performer during the 49ers 1981 and 1984 Super Bowl victories. The 5-foot-11, 208-pound Ring had the power and strength to break tackles and established himself as a short-yardage specialist. During his 6-year career (1981–1986), he played in 69 games, rushing for 732 yards and 7 touchdowns. As a receiver, he had 45 receptions for 336 yards and 1 touchdown.

Quarterback Joe Montana (no. 16) throws a 16-yard completion to his tight end Easom Ransom (no. 80) in a game won by the 49ers over the Atlanta Falcons 17-14 at Kezar during the 1981 season. Ransom played for the 49ers for 7 years (1979–1985) and 85 games, with 104 receptions, 983 yards, and 5 touchdowns.

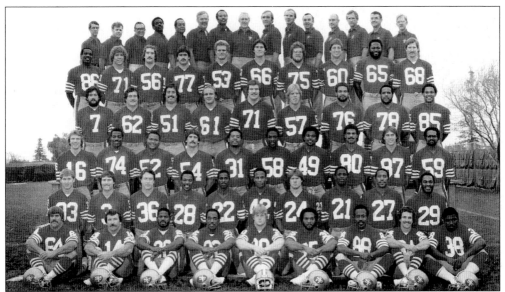

This 1981 team photo shows the 49ers Super Bowl XVI Champions. Pictured, from left to right, are (front row) Reynolds, Wersching, Lawrence, Patton, Ring, Elliott, Solomon, Schumann, and Davis; (second row) Churchman, Miller, Hoffer, Thomas, Hicks, Lott, Gervias, Wright, Williamson, and Martin; (third row) Montana, Dean, Leopold, Puki, Easley, Turner, Cooper, Ramson, Clark, and Harper; (fourth row) Benjamin, Downing, Cross, Audick, Fahnhost, Buntz, Board, Reese, and Wilson; (fifth row) Young, Stuckey, Quinlan, Kugler, McCall, Kennedy, Harty, Choma, Pillers, and Ayers; (back row) Wyatt, Vermeil, Norton, Rhodes, Matthews, McPherson, Jackson, Walsh, Banazek, Wyche, Hecker, McKittrick, Seifert, Studley, and McLean.

Outside linebacker Keena Turner (no. 58) was superb at his position. At 6-feet-2 and 219 pounds, Turner was a second-round draft pick in 1980 and played with tenacity, while his presence changed the complexion of a 49er defense that led to the team's first Super Bowl title. Three times All-Pro (1982–1985), he had 24 career sacks, 13 interceptions, and 9 fumble recoveries. In Super Bowl XVI Turner, along with linebackers Dan Buntz and Jack Reynolds, stopped the Cincinnati Bengals inside the one-yard line on three instances, then swarmed them again on fourth down to preserve the victory. Called "The Stand," it was a monumental moment in the 49ers 26-21 victory.

Freddie Solomon (no. 88) was an outstanding 49er who came to the team in 1978 in a trade for Delvin Williams. The 5-foot-11, 188-pound receiver was a constant "deep threat" with a total of 59 touchdowns by rushing, catching, or punt or kickoff returns. Solomon averaged 15.8 yards a catch and had 6 touchdown receptions in the postseason. In Super Bowl XVI, Solomon had 4 catches for 52 yards. He played eight years (1978–1985) with the 49ers.

Guard Guy McIntyre (no. 62) and other 49ers offensive linemen confer with Offensive Line Coach Bobb McKittrick on the sidelines. McKittrick coached the 49er line for 21 years, and is considered one of the most successful offensive line coaches in league history. The 6-foot-3, 275-pound McIntyre was a stalwart, versatile, agile player, and the most-decorated guard in 49er history. He played in three Super Bowls (XIX, XXIII, and XXIV), and in his 10-year career with the 49ers (1984–1993) he was chosen All-Pro five times (1989–1993) and played in five Pro Bowls (1989–1993).

Running back Roger Craig (no. 33) was an outstanding all-purpose back for the 49ers. Not only did the 6-foot, 222-pound Craig rush for 7,064 yards, but he also gained 4,442 yards receiving as one of the best double-threat backs in 49er history. Craig's best season was 1985 when he led the 49ers in rushing with (1,050 yards) and led the NFL in receiving with 92 catches for 1,016 yards. Craig had three touchdowns in Super Bowl XXIII, appeared in 5 Pro Bowls (1985–1989), and was selected All-Pro in 1988.

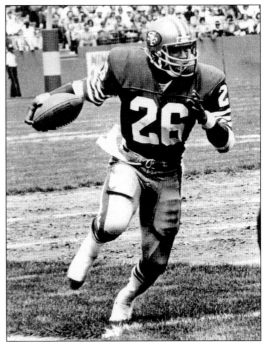

The one thing lacking in Bill Walsh's West Coast Offense was a breakaway tailback, and the 5-foot-10, 188-pound Wendell Tyler (no. 26) was the answer when the 49ers acquired him in 1983 for second- and fourth-round draft picks from the Los Angeles Rams. He immediately carried the 49ers ground game in 1983 with 856 yards, and again in 1984 with 1,262 yards and 7 touchdowns. Tyler was also an excellent receiver totaling 82 receptions and 669 yards and 6 touchdowns during his 4-year career with the 49ers (1983–1986). In Super Bowl XIX, Tyler rushed for 65 yards and had 4 receptions.

Six-foot-two, 245-pound defensive end Charles Haley (no. 94) pressures quarterback Jeff Kemp (no. 15) during a 1986 preseason game won by the 49ers 21-10 against the Seattle Seahawks at Candlestick Park. As a defensive end and outside linebacker, Haley was an intimidating pass rusher who played with an attitude and a menacing glare. Haley ranks third on the 49ers all-time list with 66.5 sacks in 8 seasons with the 49ers (1986–1991, 1998, 1999). He was selected All-Pro and played in the Pro Bowl in 1988 and 1990. He was also selected as Defensive Player of the Year and won the Len Eshmont award in 1990.

Big 6-foot-6, 293-pound Bubba Paris (no. 77) was one of the most popular 49ers tackles during his career with the 49ers. During his nine-year career (1983–1991), he played in three Super Bowls (XIX, XXIII, and XXIV) and was very instrumental in helping the 49ers win them.

Cornerbacks Eric Wright (no. 21), Ronnie Lott, and Carlton Williamson were drafted in 1981 to make the 49ers one of the best defensive units ever. Wright, at 6-foot-1 and 180 pounds, was a lock-down defender, always making big plays and vital interceptions. He led the team in 1983 with seven interceptions and was selected to the Pro Bowl in 1984 and 1985; he was an All-Pro in 1985. Wright started and played in four Super Bowls (XIX, XXIX, XXIII, XXIV). Overall, in his 10 seasons (1981–1990) with the 49ers he had 18 interceptions and 2 touchdowns, including 1 in Super Bowl XIX.

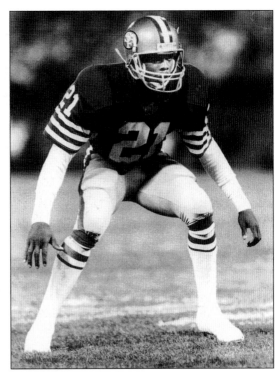

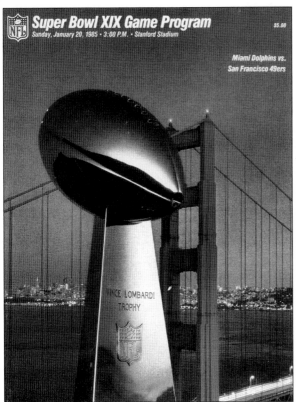

This image is of the souvenir game program from Super Bowl XIX held at Stanford Stadium on January 20, 1985. Led by Roger Craig and Joe Montana, the 49ers routed the Miami Dolphins 38-16 before 84,059 fans. Montana passed for 331 yards and accounted for 4 touchdowns. He was also selected MVP of the game as the 49ers rolled up an impressive 537 yards of total offense. They experienced their most successful regular season in team history by winning an NFL-record 15 games while losing just 1.

Offensive coordinator Mike Holmgren (left) and Bill Walsh view the action from the sidelines at Candlestick Park. Holmgren was an outstanding offensive coordinator and responsible for making the 49ers the top offensive team throughout the 1980s and 1990s.

Running back Roger Craig (no. 33), tight end Brent Jones (no. 84), wide receiver John Taylor (no. 82), and receiver Jerry Rice (no. 80) celebrate after their last minute 20-16 victory over the Cincinnati Bengals in Super Bowl XXIII played at Joe Robbie Stadium in Miami. In what proved to be the most exciting Super Bowl game of the decade, Montana connected on 23 of 36 passes for 357 yards. Before Taylor's winning reception with 36 seconds on the clock, Montana took the 49ers from their own 8-yard line, completing 5 consecutive passes to the Bengals' 10-yard line in less than 3 minutes. Following a timeout, Montana hit John Taylor in the middle of the end zone for a touchdown, landing the 49ers their third Super Bowl title of the decade.

Safety Ronnie Lott (no. 42) upends a New York Giant receiver on an incomplete pass. Lott was a dominant force in the secondary in the 1980s. His leadership created an attitude whereas his whole secondary went to the Pro Bowl together following Super Bowl XIX. During his 10-year career (1981–1990) as a 49er, Lott had 51 interceptions, scored 5 touchdowns, and played in 4 Super Bowls (XVI, XIX, XXIII, XXIV). He was selected All-Pro nine times and played in the Pro Bowl nine times (1981–1984, 1986–1990).

Defensive back Dwight Hicks (no. 22) became one of the greatest cornerbacks in 49er history. The defensive backfield group of Lott, Wright, Hicks, and Williamson became known as "Dwight Hicks and the Hot Licks." Together, the group intercepted 24 passes and returned 4 for touchdowns. In his 8-year career (1979–1985), Hicks, 6-foot-1 and 189 pounds, had 30 interceptions and 3 touchdowns. He had All-Pro years in 1981,1982, and 1984, was a Pro Bowl selection four times (1981–1984), and played in Super Bowls XVI and XIX.

In 1990 Joe Montana endured constant pain in his throwing arm with what the 49ers described as tendonitis in his elbow. He first encountered physical problems in 1986 when he injured his back in the opening game against the Tampa Bay Buccaneers. An examination revealed that Montana had "a congenital spinal stenosis associated with an acute rupture of the L5-S1 disc." Montana did return late in the same season to lead the 49ers into the playoffs.

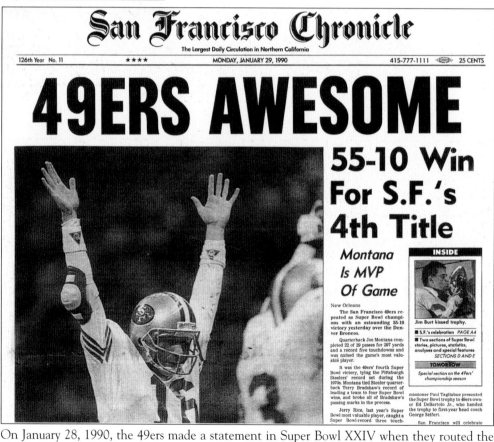

On January 28, 1990, the 49ers made a statement in Super Bowl XXIV when they routed the Denver Broncos 55-10 at the Louisiana Superdome in New Orleans. Wide Receiver Jerry Rice scored 3 touchdowns of 20, 38, and 28 yards; fullback Tom Rathman scored twice; and quarterback Joe Montana was 22 of 29 passing for 297 yards and 5 touchdowns, earning him a third Super Bowl MVP award. The game was played before a crowd of 72,919 who witnessed the most ever point total in a Super Bowl.

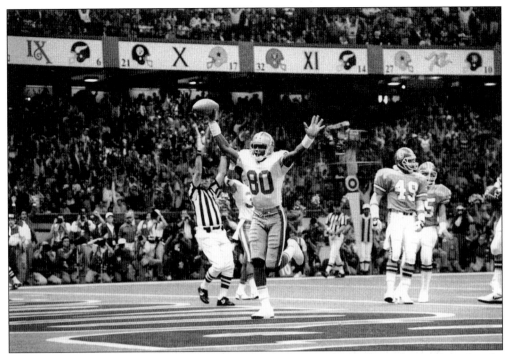

In the first quarter of Super Bowl XXIV, receiver Jerry Rice (no. 80) catches a 20-yard strike from quarterback Joe Montana for a touchdown. Rice ended the day with 7 catches for 128 yards and 3 touchdowns.

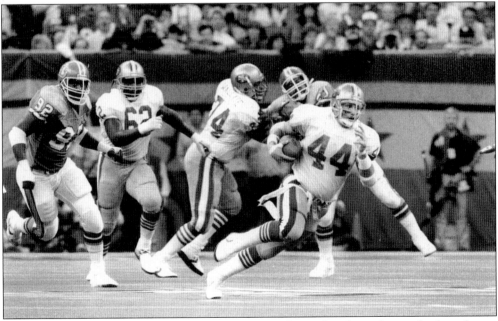

Here the 6-foot-1, 230-pound fullback Tom Rathman (no. 44) picks up five yards after taking a handoff from quarterback Joe Montana. Tackle Steve Wallace (no. 74) and guard Guy McIntyre (no. 74) provide the blocking. Rathman had a big day with a one-yard and a three-yard touchdown run in Super Bowl XXIV.

In the locker room after the 49ers 55-10 victory over the Denver Broncos in Super Bowl XXIV, safety Ronnie Lott (no. 42) gets a well-deserved embrace from owner Eddie DeBartolo for his outstanding play on defense.

Running back Roger Craig is congratulated by the media and holds the Super Bowl XXIV (Vince Lombardi) trophy proudly. Craig carried the ball 20 times for 69 yards and caught 5 passes scoring 1 touchdown. In the game, the 49ers set 40 Super Bowl records while displaying optimal performance at the highest level of competition.

SIX
Decade of Excellence and Beyond

In 1990, the 49ers finished the season with an NFL-best 14-2 mark, and came within four seconds (in a 15-13 loss to the NY Giants) of earning their third consecutive trip to the Super Bowl. The 49ers won their first 10 games (a team record) and posted an 8-0 mark on the road, giving them the longest road winning streak in history—19 games, including the postseason.

The 49ers met the Washington Redskins in the first round of the playoffs and beat them handily, 28-10. In the NFL Championship game, the Giants knocked Montana out of the lineup as he suffered a broken hand, a bruised sternum, and a concussion. He would not appear in another game for the 49ers for nearly two years. Yet Montana was named the Player of the Year and *Sports Illustrated*'s Sportsman of the Year. Jerry Rice ended the season with 100 pass receptions for 1,502 yards.

Steve Young became the starter in 1991 after four seasons as a backup, but the team was floundering. After losing four of their first six games, the 49ers won their final six in a row to finish 10-6 and in third place. Young won the passing title despite missing six games with a knee injury, as quarterback Steve Bono came off the bench and rallied the team to five consecutive wins.

In 1992, the 49ers posted the NFL's best regular season record (14-2), while winning their sixth NFC West title in seven years, and advanced to the NFC Championship game for the second time in three years. In the playoffs the 49ers defeated the Redskins, but they fell to the Cowboys, 30-20, in the championship game. Jerry Rice etched his name in football history, tough, becoming the all-time NFL season reception leader with a 103 catches.

Joe Montana was traded to the Kansas City Chiefs in 1993, as Young became the undisputed starter for the third straight season. The 49ers finished 10-6, marking an NFL record 11th consecutive season with 10 or more victories. In the playoffs, the 49ers annihilated the Giants 44-3. But, once again the Cowboys prevailed, 38-21, in the championship game.

In 1994, DeBartolo was determined not to lose to the Cowboys again and acquired a host of free-agents: Cornerbacks Deion Sanders and Toi Cook; linebackers Ken Norton Jr., Gary Plummer, and Rickey Jackson; defensive end Richard Dent; and center Bart Oates. In the draft, the 49ers came away with defensive tackle Bryant Young and fullback William Floyd. This nucleus of players contributed to what many felt was the 49ers' finest season. They finished a remarkable 13-1 over the least 14 weeks.

In the playoffs, the 49ers ran over the Bears 44-15, setting up for a rematch with the Cowboys. The 49ers got revenge with a decisive 38-28 victory. Two weeks later, Young and Rice led the 49ers to a 49-26 drubbing of the San Diego Chargers in Super Bowl XXIX and the team's fifth Super Bowl win.

Once again the 49ers captured the NFC West title in 1995 with an 11-5 record. Steve Young missed the last five games with a shoulder injury and the Packers ended any hopes for a 49er Super Bowl repeat by beating the 49ers 27-17 in the first round of the playoffs.

With a 12-4 record in 1996, the 49ers once again dominated their division and made the playoffs. In the wild card playoff game, the 49ers shut out the Philadelphia Eagles 14-0, but Steve Young suffered two broken ribs. This would doom the 49ers in the NFC divisional playoffs, as Young lasted only 9 plays and the Packers finished off the 49ers 35-14. Jerry Rice became the first player in NFL history to register 1,000 career receptions and 16,000 yards. Less than two weeks after the loss, Steve Mariucci replaced Seifert as 49ers head coach.

Although the 1997 49ers were vulnerable to injuries, they rallied under Mariucci and captured the NFC West title and advanced to the NFC Championship game. They finished 13-3, including an 11-game winning streak, advancing to the title game with a 38-22 win over the Vikings in the playoffs. Once again the Packers ended the 49ers' Super Bowl hopes with a 23-10 victory. Running back Garrison Hearst became the first 49er running back to rush for 1,000 yards since 1992. Wide receiver Terrell Owens and J.J. Stokes emerged as primary receiving targets, while All-Pro guard Kevin Gogan beefed up the offense and linebacker Kevin Greene (10.5 sacks) helped the 49ers lead the league in total yards allowed only (250.8).

In 1998, the 49ers had one of the most productive offenses in league history. They posted their 16th consecutive winning season and rolled to a 12-4 record. Young set a team record by throwing for over 300 yards in six consecutive games and threw for 36 touchdowns. Hearst set a single-season team rushing record with 1,570 yards, and his 198 yards rushing against the New York Giants set a single-game rushing record. The 49ers ended their three-year playoff drought to the Packers and beat them in the closing moments of the first round of the NFC playoffs 30-27 when Young and Owens hooked up on a 25-yard touchdown play. The following week, Hearst broke his ankle early in the first quarter of the NFC Championship game against the Atlanta Falcons and the 49ers lost 20-18.

The 49ers ended the decade with a 4-12 record in 1999. A season-ending injury to Steve Young in week three caused a tailspin from which the team never recovered. Newly acquired quarterback Jeff Garcia responded admirably, but lost 9 of the 11 games he started. The season proved to be an impetus for Garcia, who over the final five games completed 121 of 182 passes for 1,441 yards and 8 touchdowns. Running back Charlie Garner rushed for 1,229 yards and caught 56 passes.

The 49ers opened their sixth decade in 2000 under new leadership with John and Denise York at the helm. Eddie DeBartolo Jr. ended his ownership tenure after having guided the 49ers to five Super Bowl Championships and 16 postseason appearances during his 20-plus years. The 49ers finished 6-10 as Jerry Rice played his last season as a 49er. Serious salary-cap problems forced the 49ers to rely more on young players and they continued to experience growing pains. The 49er offense performed at a high level for most of the year as Jeff Garcia had an unbelievable season in breaking a franchise record with 4,278 yards passing and registering an impressive 31 touchdowns. Terrell Owens set an NFL record with 20 catches in a single game.

The 49ers were one of the season's biggest surprises and finished 12-4 in 2001. Garcia threw for 32 touchdowns and established a 94.8 passer rating, and Terrell Owens led all receivers with 100 receptions The defense kept getting better each week, giving up a combined 57 points in the last 6 regular-season games with 3 shutouts. The 49ers faced the Packers in bitter-cold weather at Lambeau Field in a wild-card playoff game and were beaten 25-15.

The San Francisco 49ers entered 2002 season with hopes of advancing past the first round of the NFC playoffs. The team accomplished the mission finishing the season with a 10-6 record, advancing to the NFC Divisional playoff with the second largest comeback in NFL playoff history, as Jeff Garcia threw a touchdown pass with one minute left in the game, giving the 49ers a 39-38 win over the NY Giants. The following week, the Tampa Bay Buccaneers crushed the 49ers 31-6 in the NFC Championship game. Head Coach Steve Mariucci was released from the final year of his contract and the owners hired Dennis Erickson in his place.

With a new coach in 2003, the 49ers slipped to a 7-9 record. Salary cap restrictions forced an exodus of several key offensive weapons, including quarterback Jeff Garcia, receiver Terrell Owens, running back Garrison Hearst, guard Rod Stone, and tackle Derrick Deese.

With a drastic change in the offense, the 49ers needed to target young talent through the draft and free agents to replace the loss of veteran leadership and experience. In the future, there might be some new faces on the sidelines and on the field, but one thing is certain: the 49ers will make sure their organization stays on top to meet the challenges and return to their winning ways.

Wide receiver Terrell Owens (no. 81) heads to the practice field at the team's training site at the University of Pacific in Stockton, California in 2000. It is not unusual for temperatures to reach the 100s during the grueling month of July.

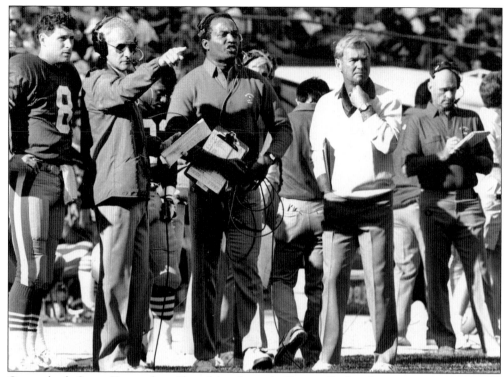

Quarterback Steve Young (no. 8) and head coach George Seifert discuss game tactics with defensive backs coaches Ray Rhodes (left) and Neal Dahlen (center) and offensive line coach Bobb McKittrick during the 49ers-Buccaneers game at Candlestick in 1990. Bill Walsh brought in the humble Seifert in 1980 to coach the defensive backs. In 1989 Seifert became head coach and accumulated a 98-30 record in 8 seasons with the 49ers for a winning percentage of 76.6—the highest in franchise history. Seifert did it with dignity, class, and an understated competitiveness he rarely displayed in public. As a rookie head coach in 1989, he won his first Super Bowl (XXIV) against the Denver Broncos with a 55-10 victory, and in 1995 he won Super Bowl (XXIX) against the San Diego Chargers, 49-26. His coaching career with the 49ers spanned 17 years, from 1980 to 1996.

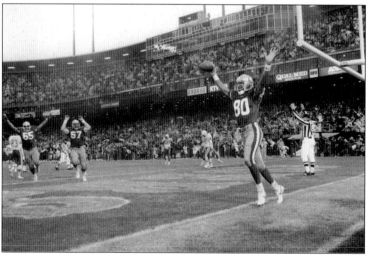

On December 6, 1992, Jerry Rice (no. 80) caught his 101st touchdown pass against the Miami Dolphins at Candlestick Park to become the all-time reception leader. Rice continued to etch his name in football history, becoming the NFL's all-time touchdown reception leader with 176 (including 10 rushing touchdowns).

SPORTING GREEN EXTRA

A PASSING ERA

BY SCOTT SOMMERDORF/THE CHRONICLE

With Joe Montana at the helm for the 49ers, no opponent was too formidable, no deficit too large, no situation too tense

INSIDE

JOE COMPARED:
How Montana's talents stacked up against the other top quarterbacks of his era **2**

JOE COOL:
What made Montana so poised when the pressure was greatest **3**

THE INJURIES:
A graphic look at the surgeries

There never will be another Joe Montana

J oe Montana came among us in the dark period of Bay Area sports. He was the bringer of light.

When Montana took over as the 49ers' starting quarterback in 1981, the Giants were still years away from getting into the playoffs, the A's were about to go through their Billy Ball period, which would end in bitterness and disintegration, and the Warriors were in the early stages of their J. B. Carroll era, which tells you all you need to know about the Warriors.

The 49ers were locked into their own tradition of awfulness, but Montana changed all that. Sure, he was only one person — there was also Bill Walsh and Dwight Clark and Randy Cross and all the other great players who contributed to the 49ers success in the early '80s — but Montana was the brightest star in that glowing cast. As time went on, he became the one unique individual who led Bay Area sports to their glorious renaissance.

It's hard to imagine that Joe won't be making one more comeback as a 49er, won't be jogging onto the field, ducking his head into the huddle, and then tucking his hands under Jesse Sapolu for the snap. His specialty was the comeback.

The 49ers might be behind in the last minutes of the game, but Montana never doubted that he would pull out victory. Walsh, the man who introduced Montana to the National Football League, says Montana never thought about losing. He was the kind of player who only thought about how he was going to get it done.

LOWELL COHN

The end of an era came in 1992 when 37-year-old quarterback Joe Montana ended his career with the 49ers in a deal that sent him to the Kansas City Chiefs.

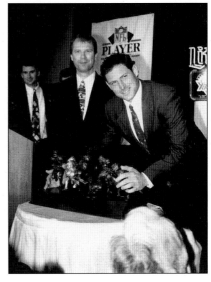

In 1992 quarterback Steve Young wins his first NFL Most Valuable Player Award and a passing title for the second straight year, finishing with 3,465 yards and 25 touchdowns. In his career he won 6 passing titles (1991–1994, 1997–1998), and had the highest rating ever of 112.8 in 1994. In Young's 11-year career (1987–1998) as a 49er, he completed 2,355 passes for 29,461 yards and 218 touchdowns. Young was also a phenomenal rusher for the 49ers with 4,182 yards and 43 touchdowns. He twice won the Len Eshmont Award (1992 and 1994) and was selected All-Pro six times (1992–1995, 1997–1998) and played in seven Pro Bowls (1992–1998).

113

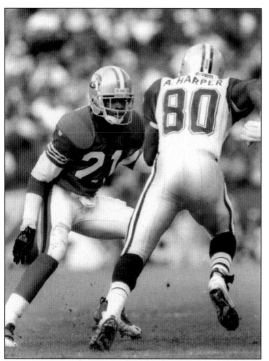

Cornerback Deion Sanders (No. 22) has tight coverage on Alvin Harper (No. 80) of the Dallas Cowboys in the 49ers 21-14 win in 1994. Sanders played only one season with the 49ers but was outstanding at his position with six interceptions and three touchdowns. He won the NFL Defensive Player of the Year honors in 1994 and was a contributor to the 49ers winning Super Bowl XXIX.

Linebacker Ken Norton Jr. (No. 51) gets ready to corral Emmitt Smith (No. 22) of the Dallas Cowboys during the 49ers win at Candlestick. The 6-foot-2, 241-pound Norton became the first player in NFL history to win 3 consecutive Super Bowl rings after joining the 49ers in 1994, and immediately helped the team to the title. Norton was a great linebacker who started 128 consecutive games, was All-Pro in 1995, and played in 2 Pro Bowls (1995–1997).

The 6-foot-4, 230-pound Brent Jones (No. 84) came to the 49ers as a free agent in 1987 and established himself as one of the best tight ends in the history of the franchise. He is the first tight end in team history with 400 catches and ranks fifth all-time in catches with 417 for 5,195 yards with 33 touchdowns during his 9-year career with the 49ers. He was selected All-Pro four times and played in four Pro Bowls (1992–1995).

The 49ers celebrate as receiver Jerry Rice's (No. 80) shining moment came in the first week of the 1994 season in a game against the Los Angeles Raiders (won 44-14 by the 49ers) when he eclipsed Jim Brown's all-time mark with 127 touchdowns.

From left to right, quarterback Joe Montana, head coach Bill Walsh, owner Eddie DeBartolo, quarterback Steve Young, and wide receiver Jerry Rice are honored at the 49ers 50th anniversary gala at Bill Graham Auditorium in San Francisco in 1996. Over 5,000 guests, including Mayor Willie Brown and other Civic and Hollywood luminaries, 49ers cheerleaders, singers from Beach Blanket Babylon, and faithful 49er fans were in attendance. During the ceremony, the 49ers All-Time team (1946–1996) was announced and each player received a lifetime achievement award. Owner Eddie DeBartolo was presented a key to the city by Mayor Brown.

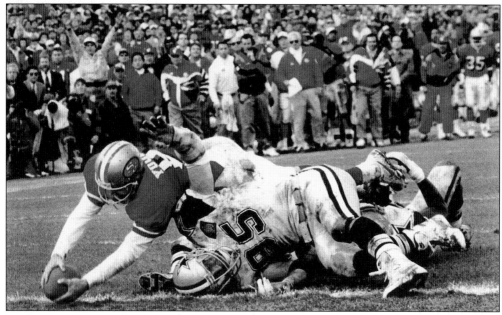

Quarterback Steve Young (No. 8) crosses the goal line against the Dallas Cowboys in the 1994 NFC Championship game won by the 49ers 38-28 before a record crowd at Candlestick of 69,143. Young's touchdown assured the 49ers that they would meet the San Diego Chargers in Super Bow XXIX.

The scoreboard reflects the mood of the stadium, "1984 NFC CHAMPIONS," as thousands of ecstatic 49er fans joined in the celebration on the playing field.

This is the January 29, 1995 game program from Super Bowl XXIX. In the game, Quarterback Steve Young set a Super Bowl record with six touchdown passes. Wide receiver Jerry Rice hauled in three scoring passes for the second time in his career in a Super Bowl. The 49ers led an offensive explosion that carried the team to a 49-26 win over the San Diego Chargers.

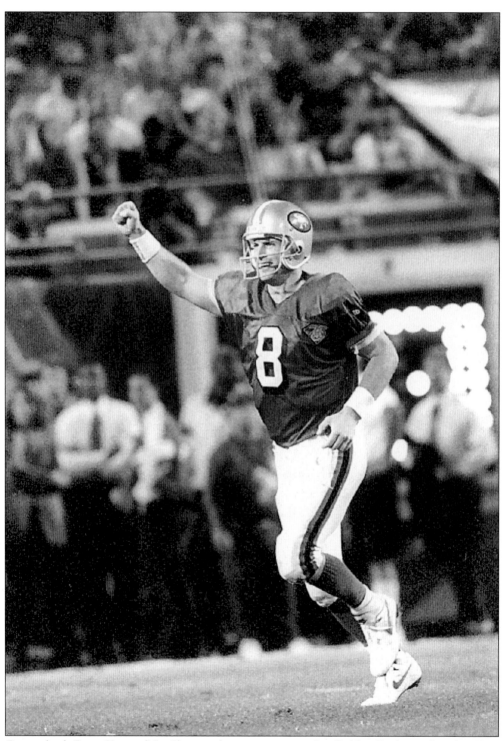

Quarterback Steve Young (No. 8) gives the victory sign at Joe Robbie Stadium after the 49ers won their fifth Super Bowl. No game could have been bigger than this one for the jubilant Young after so many years being in the shadow of Joe Montana.

Running back Rickey Watters (No. 32) was a second-round draft pick in 1991 and set a team rookie-rushing record with 1,013 yards. The 6-foot-1, 200-pound Watters led the team in rushing in 1992, 1993, and 1994 with 2,880 yards and 25 touchdowns, and caught 140 passes with 8 touchdowns. Watters established an NFL single-game playoff record with 5 touchdowns against the New York Giants in a 44-3 win in 1993. In Super Bowl XXIX, he scored three touchdowns in the blowout over the San Diego Chargers.

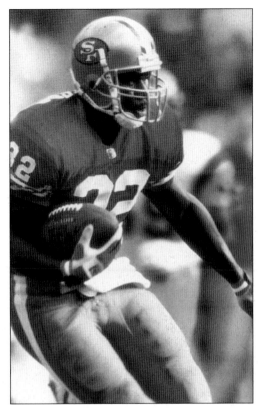

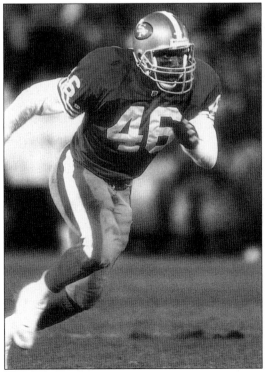

Safety Tim McDonald (No. 46) started 111 consecutive games during his 6-year career with the 49ers, and played in three Pro Bowls after joining the 49ers in 1993. The 6-foot-2, 219-pound McDonald established himself as the greatest strong safety in team history with 18 interceptions, with 3 of them for touchdowns. He played in the 1993, 1994, and 1995 Pro Bowls, and was a unanimous All-Pro pick in 1993.

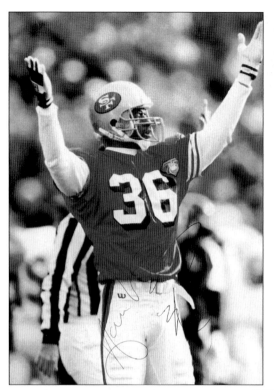

Free safety Merton Hanks (No. 36), at 6-foot-2 and 182 pounds, was an inspirational team leader and entertained fans with his exaggerated "neck" dance. In his first year in 1991, he was selected to the All-Rookie team. In his 8-year career he had 31 interceptions, with 2 going for touchdowns. He was All-Pro six times (1993–1998) and a four-time Pro Bowl selection (1994–1997).

Tough as nails, 6-foot-4, 278-pound Jesse Sapolu (no. 61) played guard and center for the 49ers for 14 years (1983–1996) and was an inspirational team leader. Sapolu was a Pro-Bowl performer in 1993 and 1994, and was the starting guard in Super Bowls XXIII, XXIV, and XXIX for the 49ers.

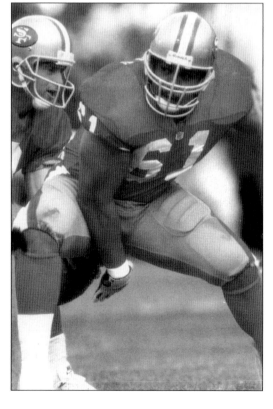

Steve Mariucci replaced George Seifert as head coach in 1997. Mariucci set an NFL record for the fastest start at home in league history, winning his first 18 games, eclipsing the 13-0 mark John Madden had with Oakland in 1969–1970. He also established an NFL record for consecutive wins by a rookie head coach with an 11-game winning streak in his first season in 1997. With 12 wins in 2001, Mariucci became only the second head coach in NFL history to win 12 or more games in 3 of his first 5 seasons as head coach. The only other coach in league history to achieve that feat is Seifert, who did it in 1989, 1990, and 1992. During Mariucci's 6 years as head coach of the 49ers (1997–2002), he won 57 and lost 39 games; he also earned four division titles.

The 6-foot-2, 302-pound Dana Stubblefield (No. 94) was the 49ers first-round pick in 1993 and teamed up with Bryant Young to put inside pressure on opposing teams. He was the starting defensive tackle on the Super Bowl XXIX Championship team and ranks sixth with 46.5 sacks on the 49ers all-time list. He was All-Pro in 1994, 1995, and 1997, and was the first player ever to win NFC Player of the Week two weeks in a row (as well NFC Player of the Month in 1997).

Quarterback Jeff Garcia (No. 5) joined the 49ers in 1999 after spending five years in the Canadian Football League (CFL), and was well suited for the 49ers West Coast Offense. At 6-foot-1 and 195 pounds, he was quick and elusive with the ability to avoid the pass rush and throw accurately on the run or take off downfield with the ball. In his first season as a 49er, he threw for a career high 437 yards and completed 33 of 49 attempts for 3 touchdowns against the Cincinnati Bengals. In his 5-year career (1999–2003), Garcia completed 1,449 for 16,408 yards and 113 touchdowns. As a rusher he gained 1,571 yards and 21 touchdowns and played in 3 Pro Bowls (2001–2003).

Wide receiver Terrell Owens (No. 81) catches a pass in front of a Green Bay Packers defender at Candlestick Park during a 1997 game won 23-10 by Green Bay. Like Jerry Rice and Dwight Clark in their primes, the outspoken Owens was a unique talent with his exceptional speed and power, and legitimately claimed to be one of the very best receivers in the NFL with 100 catches in 2002—a team record. In 2000, the 6-foot-3, 217-pound Owens set a new NFL single-game receiving record with 20 catches for 283 yards in the 49ers' 17-0 win over the Chicago Bears, topping Tom Fears's mark of 18 receptions that had stood since 1950. In his 8-year career with the 49ers (1996–2003), he had 592 receptions and 81 touchdowns. He was a three-time All-Pro player (2000–2002) and played in Pro Bowl four times (2000–2003).

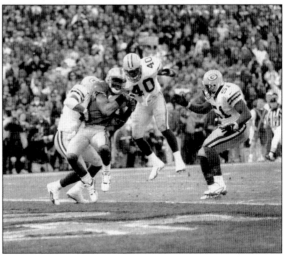

One of the most thrilling plays in 49ers history was this 25-yard touchdown catch from Steve Young to Terrell Owens (No. 81) in the end zone between three Green Bay Packer defenders with less than 20 seconds left on the clock. The 49ers had been eliminated from the playoffs 3 consecutive years by the Packers, and it looked like it would be a fourth until Owens made the catch to win 30-27 in the 1998 NFC Wild Card playoff game at Candlestick.

Hall of Famer Hugh "The King" McElhenny (right) holds up his 1954 helmet he signed for author Martin Jacobs at the annual Labor Day Sports Collectibles show in San Francisco. Jacobs, also an avid 49ers collector, has been a McElhenny fan ever since he was a youth watching him play at Kezar Stadium, and dedicated this book to him.

Fullback William Floyd (No. 40) was a first-round draft choice by San Francisco with a choice acquired from Dallas. The 6-foot-1, 244-pound Floyd set an NFL record by becoming the only rookie to ever score 3 touchdowns in a playoff game, recording 2 rushing touchdowns and 1 receiving versus Chicago Bears. Returning in 1996 from a career-threatening knee injury, Floyd was a finalist for the George S. Halas Award given by the Pro Football Writers of America to the player who most displays courage and toughness under adverse conditions. Floyd scored a touchdown on a five-yard reception versus San Diego in Super Bowl XXIX. In his 5-year career as a 49er, he rushed for 959 yards and 13 touchdowns, and had 129 receptions for 1,011 and 3 touchdowns.

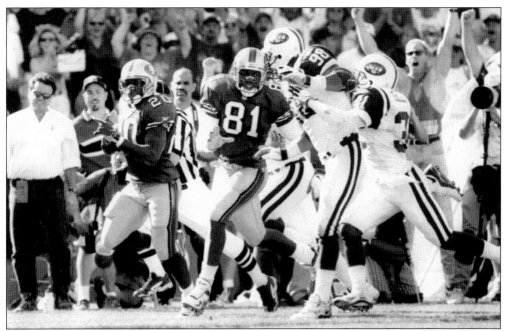

Running back Garrison Hearst (No. 20) ended a tense overtime struggle against the New York Jets in the 1998 season opener by breaking loose on a team-record, 96-yard burst for a touchdown as receiver Terrell Owens (No. 81) leads the way in 36-30 win. As a 49er, the 5-foot-11, 219-pound Hearst made an immediate impact as a powerful runner with a career high 1,570 rushing yards in 1998. He was the first player in NFL history to earn NFL Comeback Player of the Year award twice after sustaining possible career-ending injuries. He rushed for career-high 198 yards against the Detroit Lions in 1998. During his 7-year career (1997–2003) he rushed for 5,535 yards and scored 29 touchdowns. As a receiver he caught 227 receptions for 2,045 yards and 9 touchdowns, and played in the 1998 and 2001 Pro Bowls.

Bryant Young (No. 97) puts the pressure on Philadelphia Eagle's quarterback Donovan McNabb (No. 5) during the 49ers 13-3 win. Bryant, at 6-foot-2 and 279 pounds, is one of the most disruptive and dominant defensive tackles in the NFL. His impact with the 49ers helped him earn NFL Defensive Player of the Year in 1994, and he still possesses an explosive combination of speed, strength, and quickness. He is tied with Dwaine Board for third all-time in team history with 61 career sacks. In 2000, he won the team's Len Eshmont Award for the third straight year, and fourth overall (1996, 1998, 1999, 2000). Young earned Pro Bowl honors three times (1996, 1999, 2001) and was named All-Pro in 1996 and 1998.

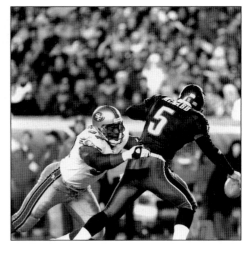

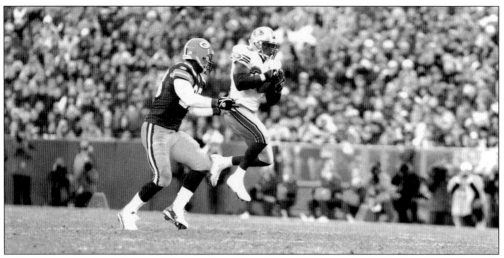

Strong safety Tony Parrish (No. 33) intercepts the ball against the Green Bay Packers in a 49ers loss in 2002. Parrish, a 5-foot 11, 205-pound durable player who consistently provides excellent coverage versus both the pass and run, has started all 64 regular season games during his 4-year NFL career and established personal single-season bests with 3 interceptions and 2 sacks in 2000. He recorded a career-high 124 tackles to rank second on the team in 2000. Parrish enjoyed an outstanding rookie season in1998, leading the NFL with 5 forced fumbles and finishing third on team with 111 tackles. He was voted by his teammates as 1998 rookie recipient of the Brian Piccolo Award. In 2003, Parrish had a career-high nine interceptions.

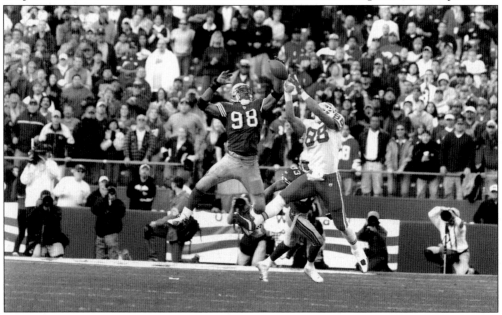

Defensive end Julian Peterson (No. 98) breaks up a pass against the Arizona Cardinals (No. 88) in the 49ers 50-14 win during the 2003 season. The 6-foot-3, 238-pound Peterson, in his fourth season out of Michigan State, has developed into one of the best outside linebackers in the league. His combination of size, speed, and athleticism is rare for a linebacker, and he has emerged as one of the top cover linebackers in the league. He was selected All-Pro and to the Pro-Bowl in 2002 and 2003.

Eddie DeBartolo Jr. presents the legendary Joe Montana his bronze bust as Montana was added to the list of the NFL's greatest at the Pro Football Hall of Fame enshrinement ceremony in Canton, Ohio, in 2000. Montana was honored for the greatness he brought to the game and the accomplishments he reached during his career. Joining Montana in the class of 2000 were Ronnie Lott, another great 49ers legend, and Dave Wilcox, an outstanding 49ers linebacker. Lott and Wilcox played the game with a passion and had the same ferocious style of Dick Butkus and Ray Nitschke. Both played every down as if it were the Super Bowl.

Jan Boehm, the ultra 49ers fan, pauses here with 49ers linebacker Ken Norton Jr. at a local autograph session. Known as "Niner Jan," she defines herself as "Niner Mom." She is known by every 49ers player for her personal devotion to them, writing to each member of the team every Christmas. Jan has built a 49ers park in front of her house, centered on a fountain of an old miner panning for gold; her home is a veritable shrine to the San Francisco 49ers. She contributed many of her original photographs of 49ers to, and is the editor of this book, as well as *Before They Were Champions: The San Francisco 49ers 1958 Season* (also authored by Martin Jacobs).

The current owners, Denise and John York, spend time with students at the 49ers Academy in Palo Alto, as well as provide financial support for the academy. The York's have been reaching out to those less fortunate for more than two decades. Whether it's constructing youth football facilities or baseball fields in the local community, or contributing millions of dollars to schools and organizations that benefit children, they are committed to enriching the lives of others in need.

Under their leadership, the "49ers Community Outreach Foundation" has become one of the premiere foundations in the NFL. It gives the 49ers players, coaches, and staff additional unique ways to be visible and interact with the fans. Over the last 3 years (2002–2004), the foundation has awarded over $3.5 million in grants to Bay Area organizations.

Denise York has more than 25 years experience in the field of sports management and real estate development and operations. From 1981 to 1991 she served as team president of the Pittsburgh Penguins, a National Hockey League team. In 2003, she was inducted into the National Italian American Sports Hall of Fame. Like Denise, John York has a multi-faceted business background with a proven record for building companies and operations, most notably founding DeYor Laboratories, and is currently president of the DeBartolo Corporation in Youngstown, Ohio. Since the York's have taken over the 49ers organization in 1999, the team has continued to be one of the NFL's premiere football organizations.